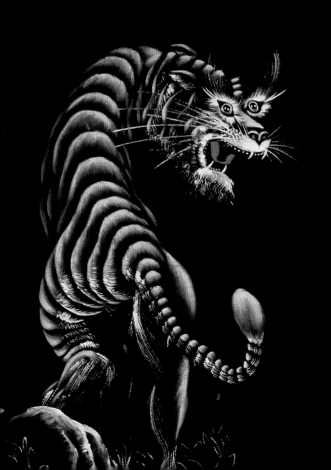

BLACK VELVET MASTERPIECES

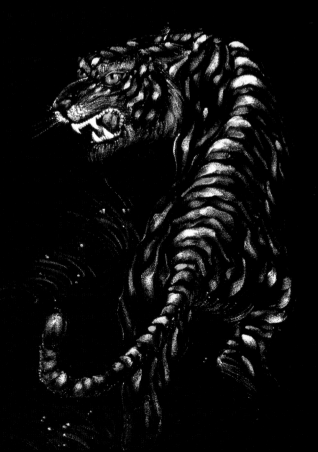

BLACK VELVET

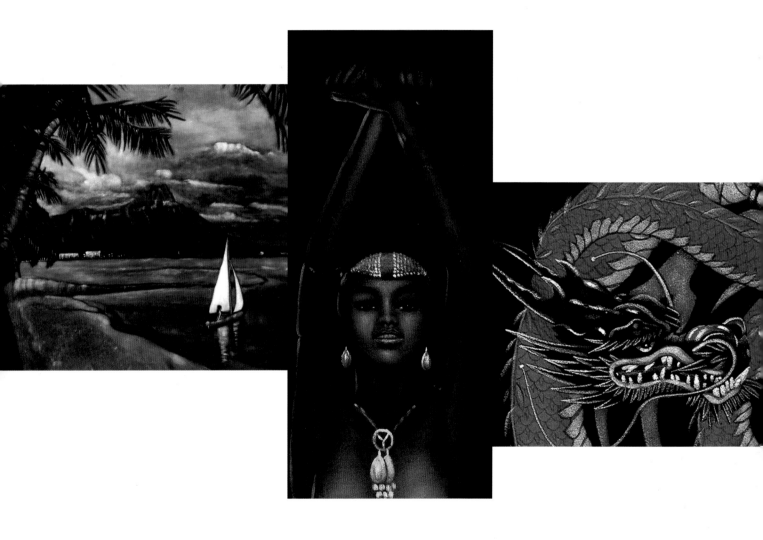

MASTERPIECES

HIGHLIGHTS from the COLLECTION of the VELVETERIA MUSEUM

CARL BALDWIN & CAREN ANDERSON

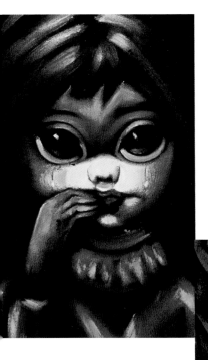

CHRONICLE BOOKS

SAN FRANCISCO

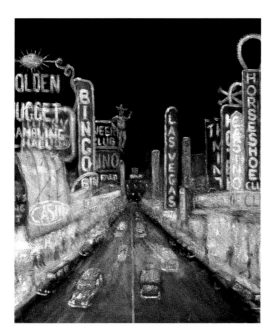

PAGE ONE
ARTISTS UNKNOWN
Tigers
1960s,
Saigon, Vietnam

ABOVE
HEANY
Vegas, Purple velvet
1964

OPPOSITE
CECELIA RODRIGUEZ
Untitled
1970s

Library of Congress Cataloging-in-Publication
Data available.

ISBN: 978-0-8118-6207-3

Manufactured in Hong Kong.

Designed by Reed Darmon.

10 9 8 7 6 5 4 3 2 1

Chronicle Books LLC
680 Second Street
San Francisco, CA 94107
www.chroniclebooks.com

Dedicated to
Jimmy Baldwin
"Keep your fists up."

CONTENTS

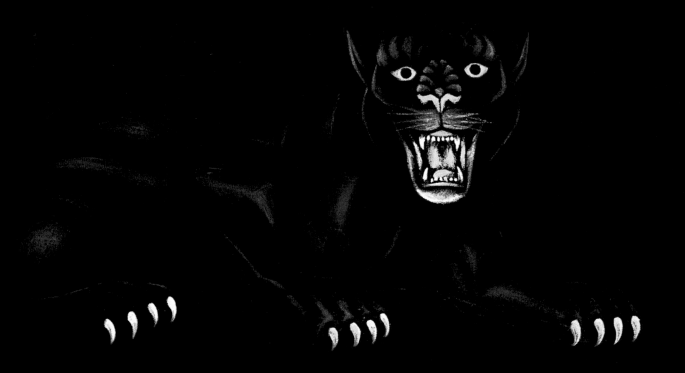

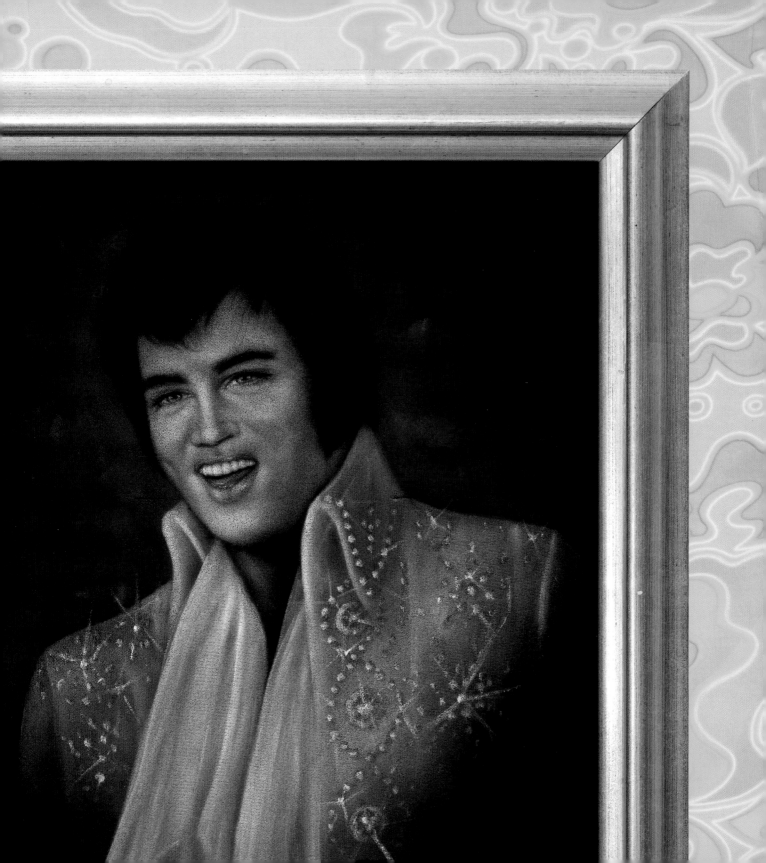

A Short History of **Velvet Paintings**

By CAREN ANDERSON

"The goal of the artist is always to deepen the mystery."
— **FRANCIS BACON**

a WEARY GI RETURNS HOME FROM WAR, a black-velvet painting of himself with a nude dream girl stashed in his duffel bag. An elderly woman in Portland, Oregon, gazes at the velvet portrait of Christ that has hung over her bed for thirty-five years, a memento of a long-ago car trip to Mexico. An Alaskan bachelor sits in his comfy chair, positioned so as to offer the best view of his black-velvet portrait of the naked blonde with big hair; he rolls another cigarette and calls her by name, "Trish." A tired man in a Toronto bar orders another drink beneath the portrait of a crying clown. And somewhere in the world, a teenager feverishly scrawls in her diary while a pair of velvet unicorns peer from the wall above her bed. They can clearly read everything she writes, but her secrets are safe.

There is something comforting about velvet paintings—dark like the womb, mysterious, and yet very familiar—a darkness that calls out for the light of paint. Velvet is soft to the touch, like very short fur, and feels like life. Velvet paintings seem to call out to the viewer, inviting them to experience the paintings in a tactile way. They have an inner luminescence that plays on the senses and lures you in.

Nevertheless, scorn, disdain, and even loathing have been heaped on this art form; some even refuse to call it art. It's the Harlequin Romance of the art world—looked down upon by some, but beloved by millions the world over, from Auckland to Manila, London to Delhi. But not everyone loves them. "These things keep popping up, like a bad penny," an art dealer said to me once, with disgust.

RAFAEL MONTANTE
Mary Washes the Lord's Feet
Early 1900s
Mexican postcard of a velvet painting

LEFT: GLORIA JONES, *Elvis*, 1970s

ARTIST UNKNOWN
Untitled
Mid-1800s
Japanese woodblock
print showing the
cultivation of
silkworms

We could start by blaming the silkworm, because the first velvet cloth was made from silk (the wonder of larvae!). The Chinese invented sericulture, the raising of silkworms for the production of silk fabric, nearly five thousand years ago (legend credits the Chinese empress Lei Tsu, consort of the Yellow Emperor, Huang Ti, who reigned from 2697 to 2598 B.C.). At first a luxury fabric meant for royalty, silk gradually became more common throughout China and Asia, and its appeal inspired the name "Silk Road," used to describe the trade routes between Asia, Europe, and the Middle East. Marco Polo (1254–1324), the most famous of the Western traders on this route, is believed to have introduced silk to Europe. He's also said to have seen paintings on black velvet in India, where the fabric also has a long history.

In Persia, weavers used special looms to join separate pieces of silk that were woven together and then cut apart, creating a new form of fabric with a short, dense pile. This fabric, known as velvet, came to Europe along with the returning Crusaders sometime between the eleventh and thirteenth centuries. Known as "the royal cloth," velvet was worn by kings and queens and used to line coffins. As a result, it became associated with both royalty and sacramental ritual (to paint a devil on such a noble fabric would have been a sacrilege). European artists were the first to paint on velvet's distinctive deep pile to re-create the look of woven medieval tapestries.

In the 1500s, Spain's empire spread from Europe to the Americas to Asia. Spanish galleons traded silk and silver between Manila and Acapulco, bringing velvet with them. In New Spain, later known as Mexico, peasants were known to have painted on velvet skirts. Velvet's journey didn't stop there. In the fifteenth century, the Portuguese introduced velvet to the Far East, notably to Japan. By the Meiji period (1868–1912), a time of newly open exchange between Japan and the West, Japanese painters had developed a unique method involving the use of indigo dyes and shaving portions of the velvet surface to give the paintings a slight three-dimensional quality that has never been used in Western velvet painting, then or now. This technique was used in treatments of traditional Japanese subjects,

ARTIST UNKNOWN
Untitled,
Cut and shaved velvet
Early 1900s
Japan

such as landscapes, flowers, and animals, all painted in this new method on light-colored velvet.

Velvet painting continued its evolution in nineteenth-century Victorian England, where young women were taught the "gentle arts." These included painting flowers, still lifes, and bucolic scenes on light velvet, called "theorem" paintings because of the use of stenciled patterns along with brushwork. This style of painting also made an appearance at about the same time in the United States, predominantly on the East Coast.

ARTIST UNKNOWN
Untitled
1920s–1930s

In the early 1920s, the New York–based French American Manufacturing Company (FAMCO) advertised hand-painted panels on black velvet, for up to $25 each. They featured reproductions of famous artists' works along with classical subjects such as King Lear and "The Fortune Teller."

the early 1930s is when our story really takes off, with the advent of the first great master of black-velvet painting, Edgar Leeteg.

Leeteg was born in East St. Louis, Illinois, in 1904. His father died when he was only sixteen, and he and his mother, Bertha, moved to Arkansas, where he worked at various jobs and took painting classes. At the age of twenty-two, he moved out west to Sacramento, California, and got a job painting billboards for the Foster and Kleiser Advertising Agency. In 1930, he took a six-week-long vacation to Tahiti, during which he was fined for reckless bicycle riding, got ptomaine poisoning from a free breakfast, and contracted a venereal disease after a night with "two island belles." When he returned to California, work was scarce in the midst of the Great Depression. A letter from a friend lured him back to the South Pacific, offering "opportunity in the Garden of Eden."

Packing some brushes and paints, he boarded a ship with his mother and a phonograph and set off for Hawaii, with the idea of making his way back to Tahiti. He stayed in Hawaii for a number of months, setting up a little poster-painting studio in the Princess Theater building in Honolulu. Leeteg had been mainly painting on canvas, but he had seen some religious velvet paintings as a youth in St. Louis and years later at a mission in California. He told U.S. Navy petty officer Barney Davis, who played accordion at the theater, that it was his goal to perfect

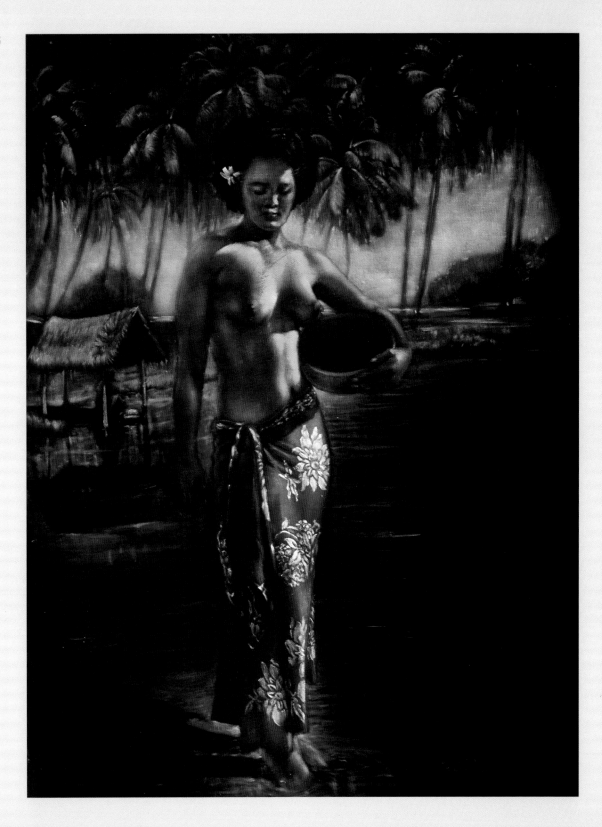

this medium and use it to capture the glory of the Polynesian race. Davis later described his first glimpse of one of Leeteg's velvet works, a portrait of a Hawaiian child: "I found myself staring at it as if hypnotized! It was my first view of a Leeteg black velvet painting! I had never in my life seen anything so real, so alive, so beautiful." After that first meeting, Leeteg and Davis would not cross paths again until after WWII. Leeteg and his mother continued on to Tahiti, arriving in 1933.

The job he had been promised fell through, and though he sold a few paintings to tourists and sailors, he mainly earned his keep by painting signs. Bertha opened a restaurant, but she soon tired of island life and returned home to Little Rock shortly after they had arrived. Leeteg left to follow her in 1935, retrieving her and returning to Tahiti. En route to Little Rock he stopped again in Hawaii, where he worked in Ollie Bader's sign shop. Bader recalled Leeteg's penchant for the ladies. "He would hand them the most outrageous lines! He wanted to paint their classic features; or they would remind him of his (nonexistent) sister or childhood sweetheart, and sometimes he told them he wanted to take them to Hollywood and get them into the movies. I had the feeling he could hardly keep his hands off them and I was afraid he might one day start to tear some girl's clothes off right then and there."

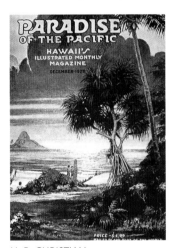

H. B. CHRISTIAN
Paradise of the Pacific
Magazine cover
December 1928

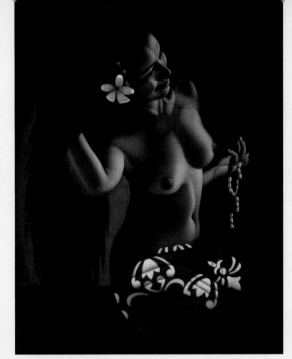

CHARLES McPHEE
Mon Desire de Tahiti
Date unknown

Charles McPhee

Charles McPhee (1910–2002) moved from his native Australia to Western Samoa in 1939 at age twenty-nine. A self-taught artist, he worked as a sign painter, a mandolin player, and, during the war, a policeman. He used servicemen as subjects for his paintings. In the late 1940s he traveled to Tahiti, where he met Edgar Leeteg, learned to paint on velvet, and fell in love with one of Leeteg's models, a woman named Elizabeth. They married and moved to New Zealand, where she was the model for a series of paintings he titled *Tahitian Girl*. The pair were famous for their elaborate parties, where food and grog never ran out. Known as the "Velvet Gauguin," he was reportedly so much in demand that at the height of his popularity his paintings "sold before the paint could dry."

EDGAR LEETEG
*Jacqueline
Cadousteau*
Late 1940s–
early 1950s

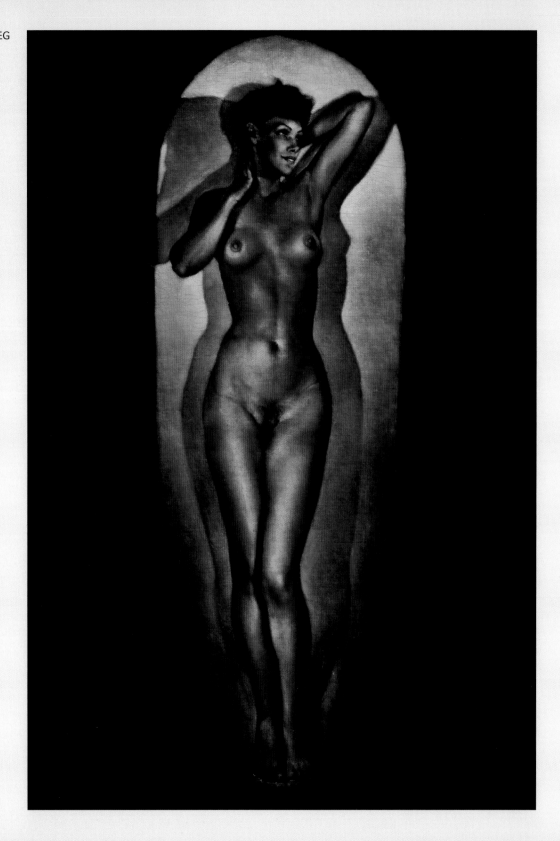

During this time, he sold his work to individual collectors for outrageously low prices, and the paintings began showing up around Hawaii, in bars and over mantelpieces. However, local art dealers turned down the velvets, planting the seeds of Leeteg's lifelong contempt for the "serious" art world. In 1938 he tried to enter his work in an exhibit sponsored by the Honolulu Academy of Arts. His work was rejected, and the $2 entry fee wasn't returned. Leeteg exploded, berating the judges for approving paintings that "looked like something on the end of a stable boy's shovel." The angry Leeteg accused them of rejecting his superior work out of fear that their own art would be eclipsed.

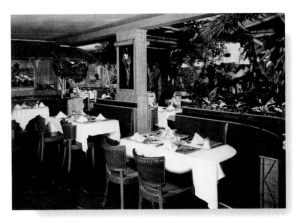

Photo of the Tropics Restaurant Waikiki Beach, Honolulu, Hawaii Early 1960s

In the mid-1940s, after the war, Barney Davis opened up a frame shop and gallery in Honolulu, and he noted that people often came in asking about "those velvet paintings" by "that guy in the South Pacific." At first, Davis didn't realize that the man he had met before the war (and known only as Edgar) and this mysterious velvet painter were one and the same. Davis set out to track him down, but nobody seemed to know where Leeteg was. He happened to spot some of Leeteg's paintings in a bar in an unsavory Honolulu neighborhood and asked about them, but the owner refused to either sell the paintings or tell him where to find the artist. Shortly afterward, a Mormon missionary stopped by Davis's gallery with two Leetegs, and Leeteg's address. Davis wrote to the artist in Tahiti and sent money for paintings to sell through his gallery, establishing a relationship that lasted until the end of Leeteg's life. Davis sold and promoted the velvets to collectors all over the world. In a letter to his dealer, Leeteg describes his process and frustration with the art world of the day: "I don't use spray guns, projectors or stencils nor any other mechanical means. Fact is I don't even have electricity. Those jealous bastards who are spreading these rumors are a bunch of liars. I use only good artist oil paints and they are applied freehand with ordinary artists brushes, this plus knowing how to use my black velvet as a medium is all there is to it."

Cover of brochure from Davis Gallery 1960s

Leeteg's paintings depicted numerous Tahitian models. Many of his paintings were of Jacqueline Cadousteau (who also bore him two children), including a beautiful portrait of her entitled *Moorea Madonna and Child*.

Although Davis was the man who promoted Leeteg and built his reputation so that his art would ultimately fetch high prices, it was a Utah jeweler named Wayne Decker who sustained Leeteg in the early years.

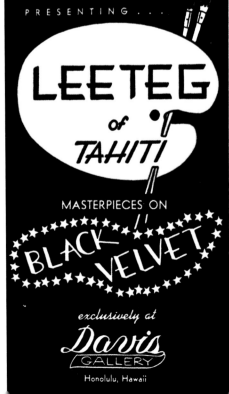

PRESENTING . . .

LEETEG of TAHITI

MASTERPIECES ON

BLACK VELVET

exclusively at

Davis GALLERY

Honolulu, Hawaii

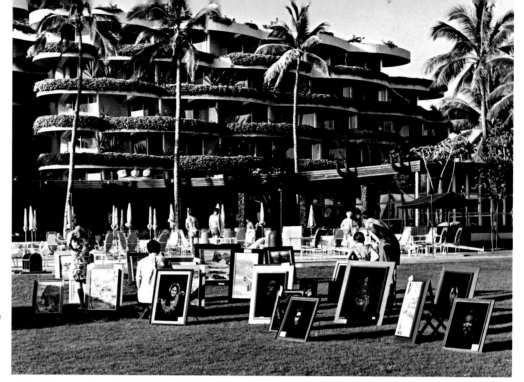

Photo of Cecelia Rodriguez and some of her paintings Sheraton Hotel, Maui, Hawaii 1968

While ashore in Tahiti during a cruise in the early 1930s, Decker entered a small store along the streets of Papeete. Along with the dry goods and various other items were some unusual paintings hung high up on the wall. The owner said they had been done on black velvet, and that the artist's name was Leeteg. Decker excitedly returned to the ship and told his wife about the paintings. The two returned the next day but were disappointed to find the wall was bare. The owner explained that another passenger on the ship, Bob Brooks, the owner of the Seven Seas nightclub in Hollywood, had bought all the paintings.

Decker left notes all over the island in the hopes of contacting Leeteg, and he found him at last before the ship left the harbor. Five "aloha" shirts and two hundred dollars later, they had struck a deal: Leeteg would send ten paintings a year to Decker in Utah, and over the next twenty or so years, Decker ended up with a collection of more than two hundred Leetegs, which he brought to various museums back East.

Leeteg wrote in a letter to Davis, "Decker took some of my paintings to New York and Washington and the museum guys raved about them but said it was not art because it was painted on velvet and they were afraid to take a chance on an unknown medium (the moss-backed bastards will wait for someone else to [do] the pioneering and only go in for a sure thing after it is proven, right now they can all go to hell—but our day is coming!)"

McHenry Village shopping center advertisement. *Modesto Bee,* June 10, 1959. Note the Leeteg painting sale price of $5,000.

Sadly, this kind of attitude about velvet painting continues to this day. Though the medium may never be appreciated by art critics, people went wild for Leeteg's paintings, and a new popular art form was born.

Leeteg died at age forty-nine in a motorcycle accident in 1953, and so he did not witness the widespread appreciation of the art he had pioneered.

However, 1953 was a big year for velvet painting: Carl, *Playboy* magazine, and I were all born. In 2005, Carl and I would open the Velveteria museum and gallery in Portland, Oregon, the largest collection of black velvet paintings in the world, and the world would never be the same.

Ralph Burke Tyree

ralph Burke Tyree (1921–1979) was an early pioneer in the Polynesian style of black velvet painting. The following information, probably written in the late 1960s or early 1970s, is printed on the back of an undated Tyree painting in the Velveteria's collection:

"Burke Tyree, the artist, was born in Irvine, Kentucky, on the 30th of June, 1921. After graduating from Turlock High School in 1939, he attended the California College of Arts and Crafts on a scholarship. Richard Halliburton and Jack London were his earliest idols, and by the time WWII was declared, Tyree had a number of experiences riding freights, stowing away on a Matson freighter, and a six-month ordeal shoveling coal on a Panamanian freighter in the Orient.

He joined the Marines in 1942, was a mapmaker for a Force Intelligence section, and later a public relations artist. Most of his tour was in the South Pacific where Samoa, with all its vivid and exotic nuances, left an unforgettable impression on Tyree. His life's work in painting revolves within Polynesia.

In 1956, after four years in Guam, Burke Tyree moved to Hawaii and first began to experiment with velvet painting. This medium dates back four centuries and had its origins in India. It is an extremely difficult medium to master, and Tyree spent eight years in experimenting before arriving at his present technique that is comparable to the velvet pieces done in France in the late eighteenth century.

Burke Tyree's velvet paintings are part of the permanent collection in three museums in England, the United States, and New Zealand. He is the only velvet artist of the past century with this distinction and it is the opinion of many that Burke Tyree is the finest painter on velvet in the world today.

The artist is planning permanent residence on the Kona Coast of Hawaii and has plans for a Trimaran to continue his search into Polynesia for adventure, color, and subject matter."

BURKE TYREE
Samoan Girl
1974

The Mexican Connection: El Paso and Juárez

One of the "frontera" border towns between the United States and Mexico, Ciudad Juárez (just across the border from El Paso) became an epicenter of velvet art. Texas writer Brian Woolley describes Juárez's main tourist strip, the Avenida Juárez, in the 1950s as a daytime bazaar of shops dealing in curios, switchblades, leather goods, and velvet paintings, and at night a haven for Americans who were looking for trouble. "As the sun went down, the spiels turned seductive: 'Hey, señors, take a look. Naked blondes.' Avenida Juárez morphed into a sleazy, Cinderella-decked-in-neon beckoning gullible Americans into the Crystal Palace, El Rancho Escondido, and the Tivoli with their big bands, tuxedoed emcees, and dirty jokes. Or, up dark and stinking stairs to raw strip and sex shows in ratty dives. On side streets were real brothels, their names too raunchy to print, advertised on fly-specked sputtering neon above their doors."

Juan Manuel Reyna, who has lived on Avenida Juárez for more than fifty years, was among the first painters to see the appeal and possibilities of painting in the medium in Mexico. In 1950, "I was brought a velvet Christ to restore. That is where I got the idea to paint on velvet," he recalled. A few enterprising individual painters who had perhaps seen a few velvets from Hawaii or the Philippines, or, as Reyna had, in a religious context, began to work in the exciting new style that immediately proved popular with tourists. Soon, according to Reyna, "A lot of people became velvet painters: housewives, students, unemployed men, everyone."

In 1964, Doyle V. Harden, a Georgia businessman who owned a small chain of grocery stores, visited El Paso and Ciudad Juárez, where he bought seven black-velvet paintings to re-sell in his stores back home. (They ended up fetching enough to pay for his whole vacation.) He came back and proceeded to empty Juárez of velvets, hauling the black gold back

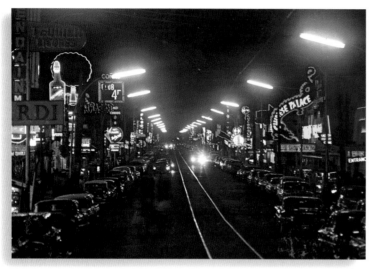

Postcard of Avenida Juárez at night 1950s

Various signatures of velvet painters from Mexico.

home to distribute to his stores. By the early 1970s, life had taken a turn for Harden. Harden divorced his wife, sold his business, and moved to El Paso, where he started his velvet-painting enterprise. Meanwhile, a Chicago businessman named Leon Korol, who bought and sold discontinued merchandise, noticed velvet paintings being sold on street corners, and thought that he could sell them too. He went to El Paso searching for the source of the velvet paintings, but to no avail. While eating lunch at a local diner, who should pull up with a truck loaded with velvet paintings? None other than Doyle Harden. Natural business partners, the two formed Chico Arts, a company that would mass-produce and sell black velvet paintings to five-and-ten stores and other retailers. By 1972, Harden had built a block-long factory in Juárez running three shifts a day. It was one of the first *maquiladoras* in Juárez, employing thousands of people. Harden would become the Henry Ford of black velvet painting. "To me," Harden said, "it is beautiful art."

Daniel Guerrero

although mass-produced velvet art was a staple of Mexico, there were some artists who stood out as greats in their own rights. Daniel Guerrero started painting on velvet in the mid-1960s; now in his late 60s, his extraordinary use of light out of the blackness created stunning works. He grew up in Tijuana and was so poor he sometimes made his own paintbrushes from locks of his grandmother's hair. As an adult he lived in the border town of Nogales, Mexico, where he painted Native Americans, campesinos, conquistadors, and nudes. One nude he painted over 1500 times. In the mid-1980s, 50 painters worked in Nogales; by 2000, when I arrived, there were no painters to be found. The disappearance of the velvet painters was as mysterious as the vanishing of the Anasazi.
— Carl Baldwin

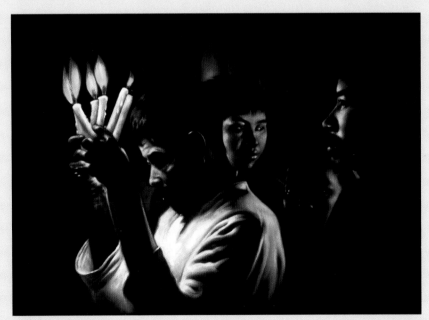

DANIEL GUERRERO
Untitled
Date unknown

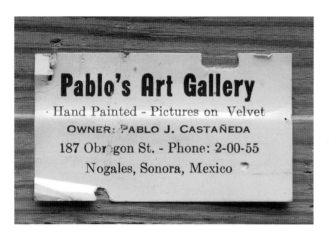

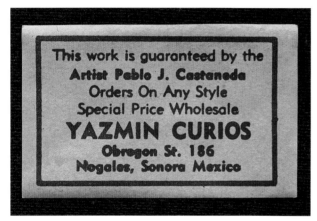

Dealer tags on the back of two Mexican paintings.

With Chico Arts came the velvet painting boom. The company shipped up to 10,000 paintings each day, with an emphasis on quantity, not quality.

"We could make much better-looking paintings by putting much more time in it," said velvet artist Jesus Moran, who worked with his brothers Chuy, Nacho, and Miguel. "Usually my brothers and I were always working. They called us the 'Zombie Brothers.'" Four painters working on an assembly line could paint ten to twenty landscapes a day: one painter did a tree, one the moon, and another added a stream. With one color, one brush, one element being added at a time, the painting moved down the line until finished. Secrets of technique were kept so as to discourage artists from breaking away to form their own studios.

Though some might scoff at the mass-produced quality of the paintings, as velvet importer Ted Kuwash pointed out, "A lot of people are laughing all the way to the bank."

Harden's artists were largely poor, and their velvet painting jobs bought them homes, cars, and a whole way of life. In fact, the painters were rolling in dough. Said Reyna, "Those of us who painted velvet, most of us were uneducated. When someone who's had no money all of a sudden gets a lot, he spends it on vice, women, alcohol, all kinds of dumb things. They had gold chains, large cars, lots of women. They were like the narcos of today. Many painters died drunk."

Harden shipped between 30,000 and 50,000 paintings a month in 1986. One week of round-the-clock shifts would produce 20,000 paintings for a single order for McCrory's five-and-dime stores. Harden sold the paintings to gift shops, malls, mobile home dealers, and a motel chain called the 8 Days Inn.

Competitors popped up all over Juárez, sending truckloads of paintings across the border to the United States. "Cleveland eats it up," said Octavio Fierro of Juárez Exports. The velvets were shipped from the Juárez factories to distributors who sold them on America's street corners and vacant lots. As the American market became saturated, exporters looked north and south to sell the velvets. In Canada, Palestinian vendors sold paintings door to door, the velvets strapped to their backs. Harden flew seaplanes into Alaska, selling paintings to residents at $300 to $400 a piece. In the late 1970s, Harden began trucking his paintings from Mexico into Central America as far as Panama. But in 1979, with the Sandinistas' overthrow of Nicaraguan dictator Anastasio Somoza, Harden lost his fleet of trucks (which were based in Managua).

In the 1980s, Scientologists picked up the velvet mantle and sold them on the streets to pay for their courses. Harden said they were one of his last big accounts. The velvet boom created a backlash, as local politicians cracked down on street vendors.

The rise of Wal-Mart and other discount chain stores forced many of the five-and-dime stores that had sold Harden's black velvet paintings to go belly-up. Tastes had also changed. In the 1980s, black lights, lava lamps, waterbeds, and velvet paintings found their way to closets, garages, and dumps, to be replaced by Beanie Babies and Nagel prints.

In Juárez, many velvet factories closed down. Most of the velvet painters shifted their talents to other trades. Some moved to Las Vegas to become ice sculptors; others turned to designing cowboy boots. In 1999, the *El Paso Times* reported that Rodriguez Curios in Juárez was selling only two or three velvet Elvises a week. "Velvet paintings of lions, Jesus, and clowns gather dust." Doyle Harden continued on for a few more years before retiring and passing the empire to his daughter, and Chico Arts found a new market in selling velvet mandalas.

On the Road Again

despite the closing of the velvet painting factories, the American market for the art form carried on into the 1990s through the hard work and long travels of roaming velvet vendors who persisted even while subject to local legal tangles for selling without a permit. Sellers such as Ken Acton were often profiled as local color in area newspapers.

Acton's sales route took him from town to town to find fresh markets and buyers. "Unicorns sell the best," he told a reporter for the *Green Bay Press-Gazette* in 1991. "Women buy 'em like crazy, or guys buy 'em for women. I guess they mean purity."

Ann Jones and son Hershel "Animal" Askins sold paintings on the road from a converted school bus, traveling from Nacogdoches, Texas, to Hamilton, Ohio. "Jesus is popular, because it is getting close to the time for him to come back, I reckon," Jones told a reporter for the *Ohio Post*, her bus parked in the parking lot of a local Color Tile. "Put it this way, even if a person don't have much money they can still put a little beauty in their homes."

Profiled in a *Milwaukee Journal* piece entitled "Selling Velvet, Street Vendor Profits from Love of Elvis, Unicorns," Bruce Cann staked out his turf selling velvets in the parking lot of the Piggly Wiggly in Kenosha, Wisconsin, selling twelve hours a day. "Lawyers drive up in Jaguars to buy Elvis for gag gifts."

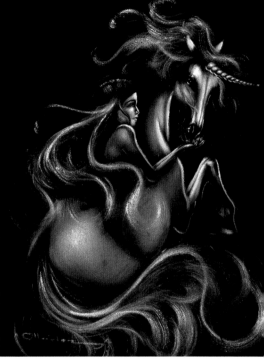

OLVIDEZ
Untitled
Late 1970s

Unicorns sell the best. Women buy 'em like crazy, or guys buy 'em for women. I guess they mean purity.

"Military bases are the best. They get paid twice a month, and there is no such thing as a depression," velvet hustler Richard Bennet explained to the *Charlotte Observer* in 1986, with his thirty-six-foot Ford bus parked next to a Waffle House. He and his wife sold paintings for $10 each, three for $25, hitting 150 cities from Florida to Illinois. "If they ever get dirty, just take it out in the yard and turn the hose on it."

Tijuana

a feisty western border town, Tijuana has always seemed a little wild. Peasants from Mexico's interior flocked to TJ for a better life, resting there temporarily before crossing over to the United States. In the 1920s, Prohibition in the States firmly established the south-of-the-border vice circuit and helped foster a local economy catering to vacationers and thrill seekers. Sailors and tourists chugged nickel beers during WWII, and by the 1950s the city had grown to roughly 60,000.

The Tijuana tourist industry was one part of the city's wild, unfettered, informal economy. In addition to cheap beer, Tijuana was brimming with cool stuff that would never be found

Postcard of colonial curio shop in Matamoros, Mexico 1960s

Stateside. Curio shops displayed bullwhips, switchblades, stuffed and mounted frogs playing instruments, rattlesnakes ready to strike, and firecrackers. You could have your picture taken with a zebra-painted donkey while you waited to have your car reupholstered or have a fender pounded out.

Mainly, Tijuana was a place to drink yourself silly and maybe get something you didn't really want from one of the nice ladies at the Club Bambi. Young sailors, with their well-developed tastes in art, searched for nudes painted on velvet like those they had seen in Hawaii and the Philippines.

Cesar Labastida arrived in Tijuana in 1953 in the early days of Mexican velvet painting. First painting on cotton shirts and dresses to sell to tourists, he soon began experimenting with velvet and painted matadors, Indians, Jesus, and movie stars, which he supplied to local shop owners. "At the time, as a boy, we sold them for $5 to the shops, large ones for $20, and they sold them for $60." He also painted tourist portraits on request. From 1954 to 1970, he finished an estimated forty paintings a week.

Miguel Mariscal came to TJ in 1962, and started painting JFK on velvet shortly after the president's assassination. "You know when a painter dies, his paintings are suddenly worth more? Not until celebrities died did people want these velvet images of them. Marilyn Monroe,

James Dean, Jim Morrison, John Lennon, I used to think I couldn't sell anyone unless they were dead." Examples of slow sellers included Linda Ronstadt, Marlon Brando, Barbara Mandrell, and Lionel Richie ("I sold maybe two of him"). However, by the mid-1980s unicorns were so hot that they overtook portraits of Elvis as the fastest-selling canvases. ET, Mr. T., Don Johnson, and Sylvester Stallone were "out." After Mariscal's gallery/stall burned down in 1983 he quickly restocked his supply of velvets, remaining in business because of the speedy work of his artists. There was no time to wait for the muse.

Painter Miguel Najera also rode the JFK boom in late 1963, but he soon found that Elvis was where the real money was. "I started out with Pino, one of the better-known Elvis painters. [We] must have done thousands of paintings on velvet. It was a factory. We'd turn out Elvis paintings like tortillas." His approach to velvet art emphasized practical efficiency. "Many of the velvet painters cannot draw. They just take a pattern of the image and kind of color it in. . . . We used to do five or ten a day. But the quality wasn't there, of course.

"Sometimes we worked so quickly we would take a wet painting and lay a fresh velvet on it and rub the image from one surface to the other. It is not worth the time to do better work. People won't buy it."

Enrique Felix was shining shoes in 1969 when he saw the velvet paintings of Raymundo Martinez, and he apprenticed himself to the more experienced artist. "He taught me everything, and then I started to practice on my own. Back then the popular ones were the bullfighters, the *Playboy* models, and, of course, Elvis." New York and Chicago wholesalers ordered Elvis velvets by the hundreds.

Finding images that would sell was the key to velvet success. "If something works, we all copy it. If it doesn't, we stop making it," said painter Jorge Avalos, who had a gallery on the Avenida Revolución.

When it worked, it worked. Avalos was able to support his family and buy a house and two cars on his velvet painting income. But, as happens with any boom, there came a bust, coinciding with a downturn in the Mexican economy in the 1980s. By 1987, Avalos was painting and

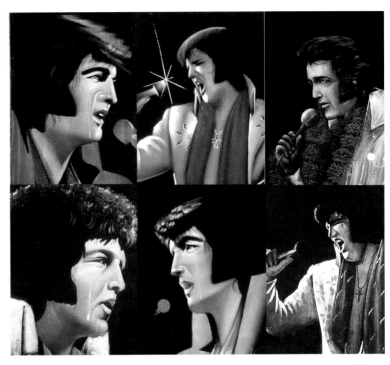

Various paintings of Elvis painted in Mexico 1970s

We'd turn out Elvis paintings like tortillas.

selling velvet paintings of cats and dogs with the inscription "I Love You" out of his van, accompanied by his two hairless Tepezcuinties. Arturo Gonzalez, who signs his paintings "ARGO," said "I see myself as an artist, but I have to make a living, and in Mexico during the crisis that was not easy. I like to paint very much, but if an opportunity arises to do something else in Mexico or on the other side, I will."

Painter Enrique Felix gave up on velvet, due to worries about his family's future. "My children are now in their twenties," he told author Sam Quinones in 2002. "I don't want them to do this. This is a good way to die of hunger."

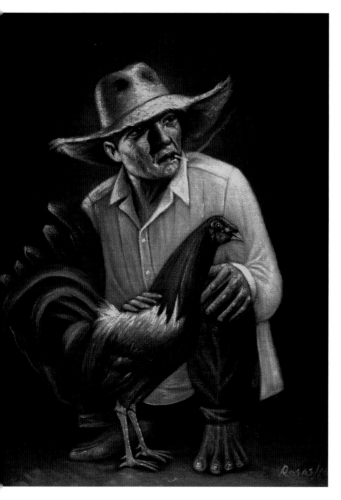

ARTIST UNKNOWN
Untitled
1960s

Asia and the Philippines

mexico and the United States were far from the only markets for velvet paintings. The love of these vivid works of art extends to Asia, including the Philippines. And that is partly due to the country's storied relationship with the United States.

The Philippines first developed a connection with the United States at the time of the Spanish-American War in 1898, when it became an American colony. After World War II, the Philippines gained its independence, but the U.S. military installations that remained on the island nation continued to operate. Under the shadow of Mount Pinatubo lay not only Clark Air Force Base but also Angeles City, the home of many velvet artists. Naturally, the servicemen who worked at the base or passed through on their way to Vietnam during the war brought back thousands of velvets from Thailand, Vietnam, and, of course, the Philippines. (It's even possible that the velvet paintings carried by servicemen traveling through San Diego from the Philippines inspired Tijuana border artists to begin painting on black velvet in the early 1950s.)

Philippine velvet paintings often depicted native hill-tribe people in traditional attire—men and women smoking, Philippine men proudly holding their fighting cocks, local women threading needles—and highly stylized nudes (some copied from photographs in *Playboy*). Portraits of American soldiers—which date at least as far back as the early 1950s, judging by the paintings in our collection—were also common, including our 1978 portrait of "Mitch" (page 128).

Unfortunately, little is known about the Philippine velvet masters. In June 1991, Mount Pinatubo erupted after nearly five hundred years of quiet, killing almost 850 people. An early warning and evacuation helped save tens of thousands of lives, but it also caused the velvet artists of the area to scatter. However, artist Ricardo San Pedro, who lives outside Manila, has made some inroads in researching their lives, giving us some sense of these painters' work. The late Felix Gonzales, who had been based in Manila, was known for his work painting custom portraits and nudes; his portraits in the 1970s included depictions of President Marcos. Painter Felix Tanglao (who has also unfortunately passed away) had been based in Angeles City, and did numerous paintings of servicemen from Clark Air Force Base, in addition to Last Suppers and native portraits and scenes. Estaban Lumanlan was commissioned by the Archbishop of Nueva Caceres in Naga City in 1961, and in 1962 he painted a custom portrait of Pope Pius in Vatican City. He is now believed to live somewhere in the United States. A common signature, Nicart, belongs not to a painter but to a dealer, who had artists sign his name to their work.

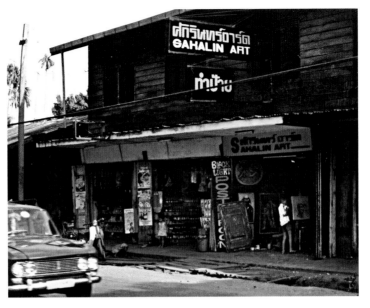

MIKE BORCHARDT
Photo of Sahalin Art
Ubon, Thailand
1973

Wherever the U.S. military went, velvet painting seems to have followed. In Korea and Vietnam, Suh Kwang Products Limited produced hand-painted velvets rendered on a round format. These featured big-eyed GIs, often depicted crying against a backdrop of helicopters or jungle scenery and an American flag, and sometimes included a blank area below the figure where the soldier could write his squad name. One example in our collection bears the inscription "Dear Mom and Dad, this is what we look like over here." It is a poignant souvenir of a horrific time. Another painting from Korea sarcastically extols the joys of the military career, the joys of service, and the benefits of reenlistment.

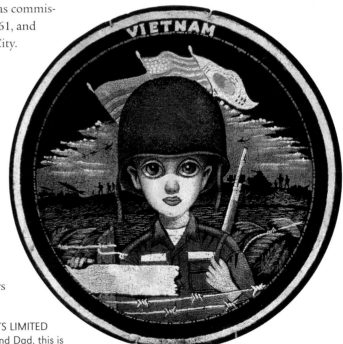

SUH KWANG PRODUCTS LIMITED
Vietnam ("Dear Mom and Dad, this is
what we look like over here.")
1960s

25

The Velvet Underground

black velvet paintings have had a long, strange appeal to those with literally criminal tastes. In 1974, ten years after Honolulu velvet art dealer Lou Kreitzman put an international spotlight on velvet painting by displaying the work of his artists at the 1964 World's Fair in New York, he and his roommate were tied up and robbed of jewelry, $3,800 cash, and "the real score": 128 velvet paintings worth $10,000.

Wielding a bayonet and rifle, the pair of robbers shot and killed one of Kreitzman's employees when the unfortunate man stopped by and knocked on the door, accidentally interrupting the crime. The day after the robbery, the paintings were recovered in Memphis, where they had been shipped. The robbers were caught and, after a lengthy trial, sentenced to prison terms of twenty years for the shooter and ten years for her accomplice.

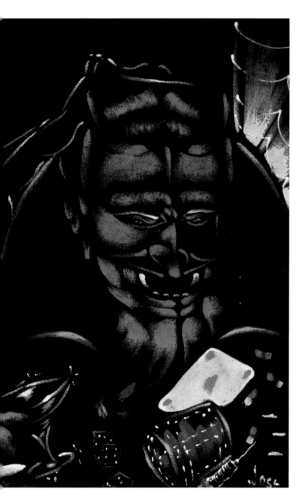

In September 1989 in Sylmar, California, police investigated the warehouse of Adriana Imports after irregular deliveries had aroused suspicion. Amid the piñatas, Mexican piggy banks, and velvet paintings the company had trucked in from south of the border, authorities also found twenty tons of cocaine and $15 million, making it one of the biggest coke busts ever. The following day, after word of the record bust got out, the *Los Angeles Times* reported that huge crowds of looters had descended on the site, picking through the rubble to scavenge unbroken pottery and velvet paintings depicting images "ranging from unicorns to Jesus with a lamb."

On October 4, 1997, a Loomis Fargo and Co. employee named David Scott Ghantt propped the Charlotte, North Carolina, depository vault door open with a stick. Ghantt and his co-conspirators (who numbered in the dozens) took $17 million, making it the largest cash robbery in U.S. history, and went on a white-trash spending spree. In the months after the robbery, they moved from a trailer park to a gated community in tony Cramer Mountain and proceeded to buy breast implants, tanning beds, big-screen TVs, a $10,000 pool table, speedboats, motorbikes, cars, a wine cellar full of Pabst Blue Ribbon beer, and a velvet Elvis. Though Ghantt had been videotaped suspiciously loading bricks of cash into a company van, it was the wild spending spree that proved to be the big tipoff.

Once the thieves were caught, their ill-gotten loot was auctioned off by the federal government, with the velvet Elvis fetching $1,650 in a fevered bidding war. The winner told the *Charlotte Observer* that he would have been willing to bid up to $6,000 for the famous Loomis heist velvet.

ARTIST UNKNOWN
Untitled
1980s

Selected Sources

BOOKS

Davis, Bernard. *Leeteg of Tahiti: Masterpieces on Black Velvet*. Honolulu: Davis Art Gallery, 1969.

Dresser, Christopher. *Japan: Its Architecture, Art, and Art Manufacturers*. London: Kegan Paul Limited, 2001.

Heath, Jennifer. *Black Velvet: The Art We Love to Hate*. Petaluma, Calif.: Pomegranate Books, 1996.

Michener, James A., and A. G. Day. *Rascals in Paradise: True Tales of High Adventure in the South Pacific*. New York: Random House, 1957.

Quinones, Sam. *Antonio's Gun and Delfino's Dream: True Tales of Mexican Migration*. Albuquerque: University of New Mexico Press, 2007.

Turner, John, and Greg Escalante. *Leeteg of Tahiti: Paintings from the Villa Velour*. San Francisco: Last Gasp Press, 1999.

Williams, C.A.S., *Outlines of Chinese Symbolism and Art Motives*, 3rd ed. New York: Dover Publications, 1976.

FILM

Velvet Dreams, Sima Urale, director. New Zealand: ON Air, 1998.

TELEVISION

McNamara, Bob. CBS Evening News, July 10, 1986.

NEWSPAPER AND MAGAZINE ARTICLES

Blake, Patricia. "Invitan a visitor la exposición 'Tijuana de terciopelo.'" *Frontera* (Tijuana), July 15, 2003, www.frontera.info/edicionenlinea/notas/noticias/20030715/27303.asp

Cearley, Anna. "The Velvet Underground: Tijuana's Once-Kitschy Art Genre Is Attempting a Comeback as Serious Art," *San Diego Union Tribune*, July 29, 2002, Lifestyle section, D1.

Ellison, Katherine. "Velvet King Defends His Day-Glo Da Vincis: Mexican Firm Keeps U.S. Supplied with Washable Art," *San Jose Mercury News*, February 3, 1989, 1A.

Gee, Harriet. "Art Theft Case Goes to Jury," *Honolulu Star-Bulletin*, June 16, 1974.

Gee, Harriet. "Man's Murder, Theft Charges Dismissed," *Honolulu Star-Bulletin*, June 13, 1974.

Gee, Harriet. "10-Year Sentence for Waikiki Art Robbery," *Honolulu Star-Bulletin*, January 31, 1975.

Gilot, Louie. "Juarez Merchants Want Shoppers Back," *El Paso Times*, June 1, 1999, Business section.

Gilot, Louie. "The Velvet Touch," *El Paso Times*, June 19, 1999, Living section.

Hofbauer, Lisa. "Painting Survival: Luck or a Blessing From Above?" *Post and Courier* (Charleston, S.C.), November 15, 1997, Edition SA, B5.

Langenkamp, Don. "He's a Velvet Painting Peddler, But The Life Isn't So Smooth," *Capital Times* (Madison, Wisc.), August 10, 1991, Local/State section, 5A.

Maish, James. *Arizona Daily Star*, September 28, 1985.

McDonnell, Patrick. "The Velvet Touch: Tijuana Artists Lure Tourists with Colorful Paintings," *Los Angeles Times*, April 11, 1987, Metro section, San Diego County edition.

Melton, Brian. "Peddling Paintings: Roadside Dealer's Business is Kitsch as Catch Can," *Charlotte Observer* (N.C.), July 29, 1986, Metro section, 1C.

Quinones, Sam. "The Henry Ford of Velvet Paintings," *Houston Chronicle*, July 7, 2004, Texas Magazine section, 8.

Quinones, Sam. "Velvet Goes Underground," *Los Angeles Times*, December 15, 2002, Magazine Section.

Sauer, Mark. "Royal Velvet: Elvis Remains the King of the Tijuana Art Market," *Daily Breeze* (Torrance, Calif.), May 1, 1992, Lifestyle section, C1.

Wecker, David. "They Travel U.S. Selling Paintings on Black Velvet." *Cincinnati Post*, July 11, 1991, Living Section, 1C.

Weintraub, Joanne. "Selling Velvet Street Vendor Profits from Patrons, Love of Elvis, Unicorns," *Milwaukee Journal*, June 25, 1991, News section, 1.

Woolley, Bryan. "A Writer Begins," Part 7. *Dallas Morning News*, August 29, 2006. http://www.dallasnews.com/sharedcontent/dws/fea/life/stories/DN-NSL_memoir7_0827liv. ART.State.Edition1.3e68755.html

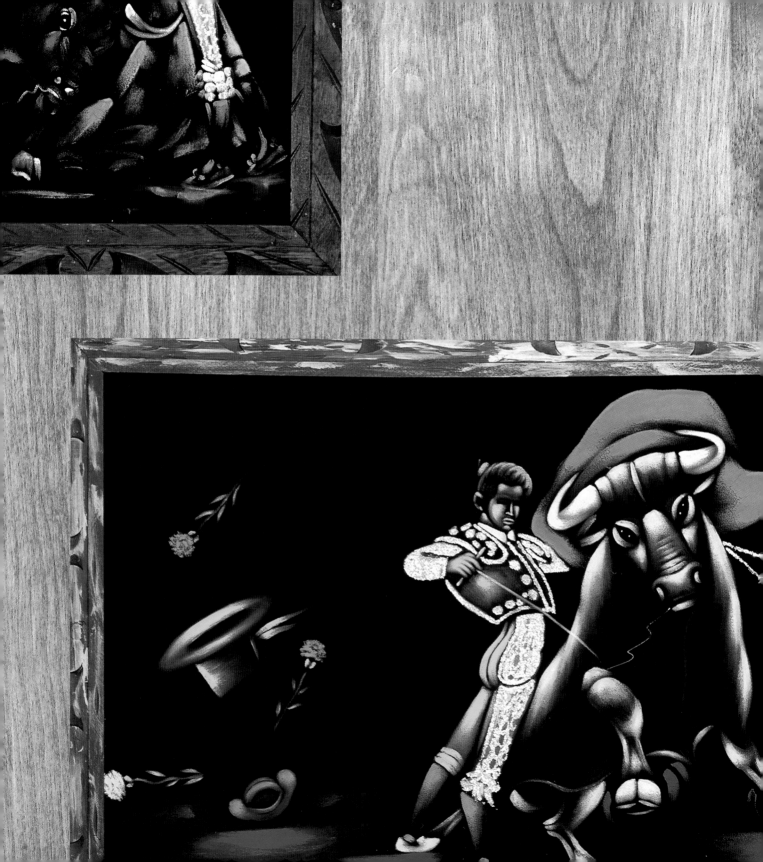

A Life in Black Velvet

By CARL BALDWIN

I T ALL REALLY STARTED IN SECOND GRADE when Miss Schoenfeld picked up the clown I had drawn, held it up to show the class, and asked, "Who is wasting paper?" I was then shipped out to Sister Clementissima, a real Captain Bligh, whose mission was to turn out Christian soldiers.

Her duty was not only to wring our necks but to wring the creativity out of our very beings. I went underground, suppressing my real thoughts for fear of facing her spanking machine. I was not alone. We all had our own Rat Fink models guiding us down the path of subversion. Ed "Big Daddy" Roth and Maynard G. Krebs were my heroes. The Mickey Mouse world would never be mine.

Our next-door neighbor, a thin, statuesque man, claimed to be a matador. He had a set of bull horns, some crossed swords, and a six-foot velvet painting of a bullfighter over his davenport. It was 1963 in Balboa, California. Dick Dale, the king of surf guitar, held court at the Rendezvous Ballroom. Velvet paintings were sold in vacant lots out of vans. The Southern California car and surf culture was at its height.

At drag strips like Lions Irwindale, Ascot, and Pomona, locals raced cars. The Beach Boys sang about hot rods, surfer girls, and our favorite spots: Rincon, Mile Zero, Doheny, and the Wedge.

We were raised in a culture of amusement: Disneyland, Knott's Berry Farm, and Hollywood surrounded us. But we also frequented (and preferred) the seedy, older places like Pacific Ocean Park in Santa Monica, the Balboa Fun Zone, and the Pike in Long Beach—which featured a huge wooden roller coaster, a real mummy, a bearded lady, tattoo parlors, broken-down carnies, sideshow freaks, and bums. It was creepy fun. It could give you the willies.

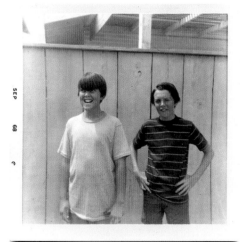

Photo of beach kids Jimmy (left) and Carl Baldwin (right) Balboa, California Summer 1968

LEFT
ARTISTS UNKNOWN
Matador paintings
1960s

Most of the lower-rent amusement parks were at the beach. Ah, the beach — always a magical place. In the '60s, still-sleepy California beach towns were not yet millionaires' ghettos. Surfers were looked upon as juvenile delinquents, and I was warned by my elders not to become a surfer: "Beach kids are rough," they said. But my brother Jimmy and I were already wild surf urchins, with our tiki necklaces and sand in our hair. We played pinball and smoked cigarettes behind the post office. At the Fun Zone one afternoon, an older guy (maybe thirteen) taught us how to tape a cherry bomb to the top of a pinball machine to blow the glass off. A midget named Elmer who ran the arcade gave chase, but he couldn't catch up, and we knew that with his poor eyesight he would never be able to give a positive ID. We hid in the black-light room of Nirvana, the local head shop, surrounded by posters of mystical castles, gothic creatures, and a velvet devil that glowed in the dark, as though he were waiting for me.

Postcard of Balboa,
California
Early 1960s

My mother exposed us to high culture and fine arts. She took us to Leonard Bernstein's symphonies for children. I witnessed, in shock, the Vienna Boys Choir at the newly opened Dorothy Chandler Pavilion in Los Angeles. The Blue Boy and Pinky were our neighbors at the Huntington Library's gallery. I even studied the violin at Ramona Convent—a girls' school—but it never took. Mama tried.

Playboy magazine provided me with plenty of imaginary girlfriends, many of whom resurfaced years later, only this time painted on black velvet, as part of the Velveteria's collection. My brother and I found a black-and-white "nature" film in our neighbor's collection and, emulating the Mitchell Brothers, we set up $5-a-head screenings in our living room for our high-school classmates during lunch hour. We were entrepreneurs!

Jimmy and I became coin divers (as in "Throw a coin to the coin divers! Largest, deepest wishing well in the world! Try your luck, Mister!"). We came by this talent naturally. Carnival was in our blood. Grandma Marguerite told us about a relative of ours, a circus fatman, whose visits worried the rest of our kin for fear he'd break their chairs. I later became a front man for a carnival dunk tank.

After a few glorious decades of wild pursuits, I experienced a series of setbacks, turnarounds, bad breaks, and back stabbings — in short, a midlife crisis.

And one day, I was going through the mail and found a commemorative book from my recent high-school reunion (I'd skipped it). Flipping though, I saw many of my old "nature" film connoisseurs, pictured with their progeny. And then . . . I saw her again. Legs crossed, in a bikini on a beach. Blonde. Smiling. The Coppertone Girl was all grown up. I picked up the phone. "Caren?"

"Yes."

"This is Carl Baldwin. From high school."

Caren asked, "Brown eyes, brown hair?" Then, "So, do you still have your hair?"

"And all my teeth, too."

We met up in Tucson, where I had a house. (Caren lived up in Portland, I lived in L.A.) I wanted to show her Tombstone and the OK Corral. We stopped at Boot Hill, saw the world's largest rose bush and the gallows at the courthouse. We had a drink at Big Nosed Kate's Saloon and were serenaded by a wiry cowgirl. We headed to Bisbee (we might as well see the open pit mines, we figured), and wandered into a junk store. There were two velvets facing each other on opposite walls: JFK staring intently across at a nude on her knees sporting a big blue Afro. The nude was $29, but Kennedy was $100. We purchased her, took her from his line of vision, and walked out. People on the street commented, "How cool." We didn't know it at the time, but we had just set foot on the Velvet Trail.

MARY
Untitled
1970s
Carl and Caren's first black velvet painting.

The Velvet Trail

We were living in Portland, Oregon —Hell's Terrarium, where I-5 meets Section 8. My shattered life had me crying like a velvet clown.

Ever-nurturing nurse Caren dressed my psychic wounds with velvet. One day we called all the thrift stores in Oregon and southwest Washington in our search for velvets, finding only a single crying clown in Beaverton, which we paddled over to fetch. Velvet fever burned out of control, and, like Patton's Third Army, we began ravaging the West Coast on our quest. At an estate sale, we found a lagoon scene that glowed eerily in the soft evening light. It was $2.

Like the Blob, the velvets began to envelop our living room, our house, and then our lives. We just couldn't stop ourselves. Two sisters, May and Linda, who ran the antique mall in Renton, Washington, told us they had a lead on a nude, and maybe a few more where that came from. After making a few calls, we drove

CAREN ANDERSON
Nurse
2001

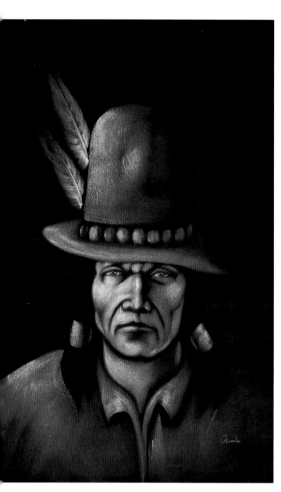

ARTIST UNKNOWN
Indian with Hat
1970s

north from Portland and pulled in behind an old bar in downtown Renton for the meet. Linda popped open the trunk of her long black Cadillac and out they came: Maria, a Mexican beauty; a red-haired vixen; and another luscious creature with light-pink lipstick. Was this Russ Meyer's old Caddie? Linda had more paintings than we'd expected, or could afford, but we needed them.

Back to the ATM we went, with the lyrics of the old Paul Davis tune running through our heads: "When I look in your eyes I go crazy . . ." We continued to spend my nest egg on velvet paintings. What were we doing?

When we weren't blowing cash in a velvet fog, I was vending beer in Seattle for the Mariners (I'd go up for the home stand and spend my nights in seedy motels and honky-tonk campgrounds). During the day I'd prowl the local thrift stores: Vinnie's (a.k.a. St. Vincent De Paul), Sal's (Salvation Army), Willie's (Goodwill), and any open garage or flea market. Sal, Willie, and Vinnie were very good to us. At the Midway Flea Market near the Sea-Tac airport, I spied a velvet painting of a large bass and some mallards on a table full of buck knives and crystal key chains with 3-D pictures of unicorns or the Virgin Mary (your choice). Working the market, we made connections with clerks and shop owners and even customers, once following a man directly to his apartment, marching into his living room, and waking up his roommate so we could buy a large portrait that resembled Tom Sawyer's nemesis, Injun Joe.

We had more than forty paintings, but not a single Elvis. We finally scored one in Puyallup, Washington, paying $80 for the King in a white jumpsuit. On the road after hard days of searching, I would return to my grimy hotel for the night and decorate the room with my masterpieces. The maids always appreciated their beauty.

I met up with a punk rock band at the Sunset in Ballard for a cache of velvets. Some time later, venturing across the border into Vancouver, British Columbia, I waited on word about a painting while an overly attentive antique-shop owner passed the time by dressing me up like a Roman centurion. And Caren and I did find an actual centurion (or at least a charioteer) on velvet. On another trip, while driving north from San Francisco, we pulled off I-5 for a pit stop in Coburg, Oregon, and spied at least twenty velvets through the window of an upholstery shop. The owner, Joe, was about to close the shop, but let us in to see the wall of paintings (charioteers, banditos, landscapes, Cortez, and more) that he fondly referred to it as the "wall of shame," the paintings all donated by customers. We bought them all on the spot.

The next biggest score was in a vast parking garage turned junk shop called RampArts in Tacoma, Washington, run by an eccentric but sweet guy named Dave. He had thousands of items

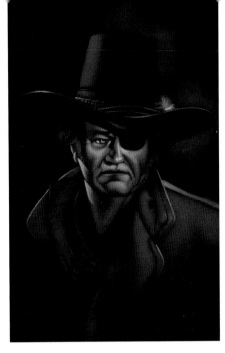

LOAIZA
John Wayne
1970s

piled all the way up to the twenty-foot ceilings: chairs on a desk placed on a table, topped with more chairs and lamps teetering above—towering expressionist heaps out of *The Cabinet of Dr. Caligari*. The aisles were ant-farm narrow and required moving sideways. Scattered throughout the shop, way up high, were thirty or so velvet paintings. We spied a Last Supper and Dave got a wild look in his eye and started to climb up the teetering tower of furniture, saying, "Watch and learn." We handed him the gaffe hook, and he snatched down the work and handed it to us. Like a monkey climbing a coconut tree he snagged clowns, John Wayne, and a Spanish galleon, although the sad clown on deep magenta velvet was hard for him to part with—he was partial to clowns. All the while, as Dave climbed up and down, Tom Waits blasted through the shop's speakers.

Dave kept replaying his favorite Waits song, "Table Top Joe," and singing along. We went back a few more times to see Dave, and then he was gone. The man who rented the place upstairs said that twenty huge trucks had come and hauled everything away. This is how life goes.

Mexico

In 1965, my father, brother Jimmy, and I took the Fury station wagon from Tucson to Guaymas one Easter vacation. We stopped in Nogales, Arizona, got our papers in order, gassed up, and drove across the border through Nogales, Mexico — a dusty, squalid town wedged in a canyon and divided by the main highway and railroad tracks. Its main features were tourist gambling and drinking haunts like La Caverna restaurant, the Frey Marcos Hotel, and the Regis Salon de Licore. We drove the torturous road to Guaymas. "Despacio," the sign read. "Go like hell!" was my father's interpretation. "We're all going to hell" is more like it, I thought.

Delicados cigarette package

When we arrived I really wanted a bullwhip, but my dad wouldn't go for it. We got Chiclets and Mexican soda instead.

Some thirty-five years later I was heading back across the border on the Velvet Trail. I parked near McDonald's in Nogales on the U.S. side, walked past the Safeway, down the hill to the border,

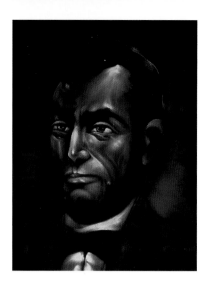

ARTIST UNKNOWN
Abraham Lincoln
1970s

through the iron turnstile, and stepped into Mexico. A gauntlet of "amigos" were eager to help me find what they thought I was looking for: Valium, codeine, or other contraband. "My friend, what do you like? What are you looking for?" "*Pinturas de terciopelo negro*," I said. "Black velvet paintings." No one really knew what to do with that, but they tried anyway. "Come in here. Have a look," they said. I stopped at Mickey's Department Store on the main drag. They sold Cuban cigars and had a world-famous tequila fountain. Taking a complimentary shot, I looked up and saw a velvet painting of a big-eyed kid. Not quite a Keane, but close. I bought a beer and quizzed the shopkeeper. He said, "No. No more. They don't do it anymore. All gone."

Photo of an Argo
painting of Bob Marley,
Tijuana
2001

I continued through the maze of *tiendas* and stands. Nada. I took one final spin through another goat path and there he was: Abraham Lincoln on velvet. Abie, baby! "Ode to Joy" broke out in my head. I peered into the shop and it was as though I'd found the Lost Dutchman Mine: three stalls packed with velvets from the late '60s, which might have sat right there for the previous thirty years. Panthers, banditos, psychotronic Jesuses, nudes, embracing couples, and more. Some were tattered, but most had survived the decades of scorching summers and freezing winters. The shopkeeper's assistant, a young man of about fourteen or fifteen, spent hours with me picking through paintings.

"Look! King Luther!" he exclaimed. Martin Luther King Jr. and Abe Lincoln, together on velvet in Mexico. I met Efraín, the owner. He wanted $100 apiece. "They have been sitting here a long time," I said. I picked out some and then we talked some more. We negotiated; we haggled. I winnowed it down to my favorites. I left him to contemplate my final offer and went for a drink. When I returned, he had them parceled up and ready to go. We had cut our deal.

"But, please," he said. "How about $300? You see, I am just a poor Mexican."

"Okay, here is $320. Throw in Eve with the apple here and now you are a rich Mexican."

I made several trips to visit Efraín, eventually cleaning him out.

Efraín said, "You are going to sell these and make even more." "No," I said, "I am going to open a museum where everyone can see them. Who were these painters? Where are they?" "They are no more," was all he said.

Walking past Regis Licores and the Farmacia de Jesus, I crossed back across the border, pockets empty and arms full of velvet paintings. The border guards waved me through.

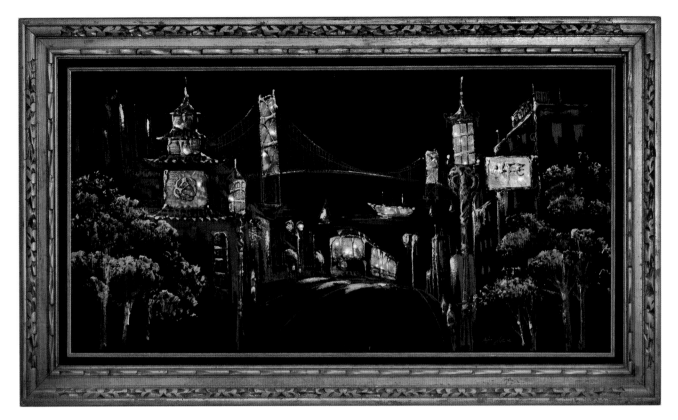

I decided to visit an old fishing spot, Peña Blanca Lake, and set up camp in the dry riverbed. All night long, groups of migrants scurried past me hoping for freedom in *los Estados Unidos*. If they had taken time to look, they would have seen that I had decorated my campsite with my new artwork.

H. LEE
*Chinatown,
San Francisco*
1970s

The Hunt Continues

In May 2001, we scored a beautiful Elvis in Burbank, a Rooster Cogburn in Ventura, and some sea horses in Pasadena, and headed north to San Francisco. Once we arrived there, an old hippie woman in an antique mall told me where I could get a nude. She said, "You will have to ask for it behind the counter. It is kind of disturbing." Disturbing? I thought. In San Francisco? "What's so disturbing about it?" I asked. "She's in the throes of orgasm," the woman whispered. I followed her directions to an old Rexall store, paid my $35, and left.

What a steal.

Across the Bay at Alameda Point Antique Fair, we found a bandito on a shield with a crown and flanked by two griffins. In Fresno, we discovered our first velvet with lights embedded in the painting: a very large scene of the San Francisco Bay looking toward Chinatown, featuring Grant Avenue and cable cars.

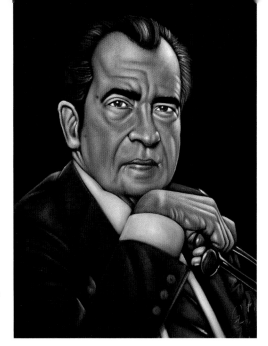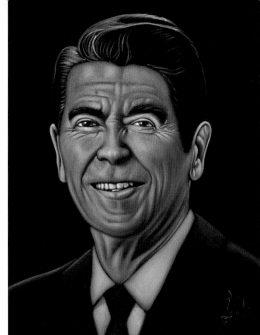

AZCONA
President Nixon and
President Reagan
2001

On a later trip to Los Angeles we scored some nudes on Sunset Boulevard. Leaving the Dresden Restaurant, we bought a velvet Vampira from a nearby store called the Archaic Idiot. With the border so close, Mexico beckoned—and this would be our first time there on the hunt together.

The next day we headed south for San Diego and Tijuana. We walked across the border through the metal one-way gate, over the aromatic Tijuana River, past the hawkers and *farmacias* to the Avenida de Revolution. Down the side streets were myriad velvet paintings. We saw Elvis, Aztec warriors, Jim Morrison, Jimi Hendrix, Duke Wayne, and Michael Jackson. There was Princess Diana, JFK, Marilyn Monroe, and Our Lady of Guadalupe, along with various versions of the "Man's Ruin," Reagan, Nixon, Jack Kevorkian, and even the Hale-Bopp comet guy from the Heaven's Gate suicide cult. We could only carry so many—maybe forty or fifty—the half mile back to the border. As we walked, it started to rain heavily (luckily the paintings had been wrapped in black plastic). The U.S. customs official asked curtly as we stood soaking wet with our bundles, "What are you bringing back?" In unison, we declared, "Velvet paintings." He looked at us oddly and waved us through.

We continued to Arizona, finding sand paintings and kachinas, but hardly any velvets. I knew Efraín in Nogales would have more (this was before we depleted his supply). It would be my third visit to Efraín, but Caren's first. My plan was to use Caren to distract Efraín and maybe lower the prices. With her body, she could change any man's mind.

Once we got there, Caren was astonished at the trove of velvets. We spent hours picking out all we could carry back. At the border, we were told to wait by a wall. "Over there," the guards said. Maybe our papers were not in order? Caren's life flashed before her eyes as she wondered whether she made another bad choice in a man. But after answering some routine questions, we were back in Nogales, Arizona, at the McDonald's for a celebratory ice cream cone.

The Velveteria

By CAREN ANDERSON

"When a true Genius appears in the World, you may know him by this sign, that the dunces are all in confederacy against him."

— **JONATHAN SWIFT**

twenty-seven years after my high-school graduation, I was in New Orleans. It was 1998, and I was having my fortune told by Madame Coco at the Voodoo Museum, in a room filled with plants, while being eyed by a white boa constrictor in a glass terrarium. She told me my color was pink and that I should wear lace and pay attention to the moon, and that in 2005 something very amazing, very over-the-top creative would happen.

Two weeks later, Carl called me, and we started our journey down the Velvet Trail.

Some years into this journey, we returned to Portland after a trip that had taken us to South America, then Utah. We looked at each other one night, the house cluttered from hell to breakfast in velvets. The time had come. We had to open the Velveteria, if only to clear our living space. How would we curate a museum? we wondered. We figured that the only difference between museum curating and the carnival was the cotton candy.

"Who would come to the Velveteria?" I asked. "What would the real art people think?"

Carl yelled, "Who cares what they think?"

We joked about supplying masks at the door so that visitors could remain anonymous. Mexican wrestling masks, perhaps. Or maybe we should be wearing the masks. I came up with a sign that read:

LIFE-CHANGING EXPERIENCE WITHOUT WALKING
ON HOT COALS OR CRAWLING OVER BROKEN GLASS
THREE DOLLARS

We chose Esperanto as our official language and vowed only to do interviews in Esperanto. We were later put to task when some

Advertising for the museum
2006–2007

37

visitors were actually fluent in the tongue and we only knew how to say "*Saluton.*" Despite this, and all our trepidations, we knew the stars were aligned. It was 2005.

We rented the museum space in October of that year, and it dawned on me that this was it. This was what Madame Coco was referring to. I said, "Carl, we must open this museum before this year ends." With tiger-striped carpet in the Naked Lady Room, abalone shell lamps, Dalmatian print fabric covering a bare cement wall, hot-pink crushed-velvet curtains hanging in the doorway, two hundred velvet paintings on the walls, and a velvet rope for crowd control, we opened to the public on December 12, 2005. Two people showed up that day.

Already having wrecked our lives a few times each, we stuck with it, and the visitors began to turn out. As folks came in from the Portland rain, they would break out in squeals of pure joy. One man in his fifties proclaimed loudly, "I'm sorry, but I love this." We told him he didn't need to apologize. One young man threw himself on the carpet and rolled around, moaning, "I could stay here forever." One woman from California exclaimed, "I want to be buried here!" (Sadly, we don't do weddings or funerals.)

Dr. Kitch

ne wet afternoon six months after we had opened, the phone rang at the Velveteria. The voice on the end of the line said, "Hello. My name is Wendy and I have a friend who has a couple hundred velvet paintings from Hawaii and Tahiti. Have you ever heard of Edgar Leeteg?"

Wendy's friend, a doctor, wanted to sell his whole collection.

His name was Dr. Kitch. Dr. Loran Kitch. (We thought, You've got to be kidding.) Wendy continued on, describing the collection. He had two original Leetegs, one of which had been owned by Virginia Loew, wife of theater magnate Arthur Loew.

Letter from gallery owner Lou Kreitzman to Dr. Loran Kitch 1976

Royal Hawaiian Fine Jewelry, Inc.

INTERNATIONAL MARKET PLACE
Honolulu, Hawaii 96815
Phone 923-6376

2273 KALAKAUA AVE., SUITE 209-A
HONOLULU, HAWAII 96815

Also At
KONA-HILTON HOTEL
Kailua, Kona, Hawaii
Phone 253-235

Artist Village

ORIGINALS . . . HAND PAINTINGS
THE LARGEST COLLECTION OF BLACK VELVET PAINTINGS IN THE WORLD
ORIGINAL LEETEG PAINTINGS

April 23rd 1976

For
Dr. Loran W. Kitch
939 E Walnut St
Suite 300
Pasadena, Calif. 91106

To Whom It May Concern

One Original Leeteg painting, on Black Velvet, by Edgar Leeteg of Tahiti, size 24X36 painting is a Polynesian girl, full nude,

Ce Ce Rodriguez

Cecelia "Ce Ce" Rodriguez was born in 1920 in Culver City, California. Rodriguez's father worked in the movie industry, for Universal and MGM. In 1960, she was working at an electronics plant in Palm Springs, California, for a dollar an hour, and in her spare time she painted portraits on masonite. During a two-week vacation to Hawaii, she saw a shop full of black-velvet paintings and thought, "I can do that." She moved to Hawaii shortly afterward, going to cooking school and waitressing while teaching herself how to paint on velvet. From other Hawaiian velvet artists she learned the technique of painting "softly"— in thin layers—so that the paint wouldn't crack when it dried. Her paintings were sold primarily through the gallery of Honolulu dealer Lou Kreitzman, who represented many velvet painters and took velvet paintings to be displayed in the Hawaiian pavilion at the 1964 World's Fair in New York. Kreitzman's gallery gave Rodriguez's work international exposure.

Rodriguez also displayed her paintings at the Maui Hilton, the Kaanapali Beach Sheraton, the Maui Surf hotel, and the Royal Lahaina under the famous Banyan tree. The velvet she painted on was imported from Lyon, France.

With the Mexican velvet explosion in full swing in the mid-'70s, the low prices and campy subjects of the Mexican velvets began to devalue the medium, even Hawaiian-style paintings, in the eyes of art gallery owners. Rodriguez hasn't painted on velvet since 1975, when her gallery told her, "We can't sell those in here." "The Mexican velvets ruined it for me," Rodriguez said. "They were selling for five bucks." She now lives in Nevada and continues to paint, on rice paper, and make collages.

CECELIA RODRIGUEZ
Untitled
1960s

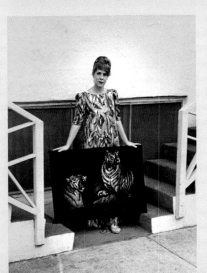

Photo of Cecelia Rodriguez with *Tigers,* Oahu, Hawaii
1965

39

BURKE TYREE
Reri
1972

Like many of the characters we met on the Velvet Trail, Dr. Kitch had a taste for the ladies, and the collection included many nudes. There were paintings by Burke Tyree, Bill Erwin, and Cecelia "Ce Ce" Rodriguez. This was the mother lode, and Dr. Kitch knew it. He wanted an ungodly sum of money. Carl drove down to the California desert in triple-digit July heat to meet Dr. Kitch and Wendy and the velvet *wahines*.

They lived on an old undeveloped four-square-mile hunk of land known as The Groves (eucalyptus groves). All around, bulldozers and earthmovers ripped and clawed away the last of old California to make way for more concrete sprawl. Carl met Wendy and Holly, Dr. K's daughter, at a country diner and followed them to The Groves. Here the doctor lived in a Dodge conversion van amid the dust, chicken coops, carpet on the drive to keep the dust down, a few marble statues, his office, and his collection housed in a railroad container car, which they examined with flashlights. It was astounding. It was a huge decision for us, but we took the leap. Dr. Kitch, a natural-born raconteur, gave some details of his life. He had been a successful oral surgeon in Pasadena. He had collected velvets in Hawaii in the 1960s. In Waikiki, he had once spied a velvet painting of a Chinese man through an open window and inquired about it from a woman who turned out to be the artist. "Do you have any more of these paintings?"

"No." She told him she was learning cake decorating now.

"Listen," he said, "If you can paint like this, this is what you should be doing. I'll buy everything you can paint."

That was the first meeting of Dr. K and Cecelia Rodriguez, now in her late eighties. True to his word, he bought her paintings over a period of years. "He kept me in money," she related to us.

He got his first Burke Tyree paintings from an old girlfriend who had come across them in a bar in Modesto, California, in the late 1960s. ("I don't know what she was doing in that bar," he said to us, looking disgusted.) Over the years, he continued to buy Tyree's work, including sumptuous nudes and stunning animal portraits. He personally knew Bill Erwin, an artist who got his paints from Leeteg.

Dr. K and Wendy delivered the two-hundred-plus velvet stash to Portland in a U-Haul. It was then that we knew we had a truly world-class collection.

Some Notes on Velvet Painting
Style and Technique

By CAREN ANDERSON

Velvet paintings can be done in acrylic or oil-based paints (the great masters used oils, while paintings done with a greater premium on speed employ acrylics). One visitor to the Velveteria from East Los Angeles has suggested that the especially vibrant color on some of the paintings may be the result of using leftover neon and candy-colored paint from auto body shops, particularly those that specialize in low-riders.

Some artists use only brushes, while others use more technical equipment such as airbrushes, or processes such as beaming an image onto the velvet canvas using a projector. Some artists place an image face-up on top of a canvas, poke needle holes to outline the image, and then dust the surface with a light-colored powder to leave an outline on the dark velvet underneath. Mexican artist Daniel P. Marquez used sharpened pieces of soap to apply his image to the velvet before painting. "You cannot really draw with pencil on black velvet," he explains. (One of Marquez's paintings graces the cover of Sam Quinones's book *Antonio's Gun and Delfino's Dream: True Tales of Mexican Migration*.)

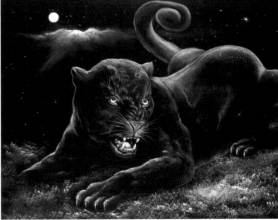

MEDINA
Untitled
2001

A number of contemporary black velvets appear to be executed using a silkscreen process, and artists working fast may press the surface of a still-wet canvas onto another, leaving a light mirror image from which to start painting the second canvas.

Artists from the Philippines tended to apply thicker coats of paint, and support their paintings with wooden backings (the thickness of the paint prevents the paintings from being rolled up without cracking).

Paintings from Hawaii, Tahiti, and the Philippines are generally on high-quality velvet with a good, dense nap. Mexican paintings tend to be on velvet with a relatively thinner nap, were often done using assembly-line techniques that enabled mass production, and were either unsigned or signed by the factory owner. Unfortunately, working conditions in Mexican mass-production operations were often poor, and the materials toxic—for instance, tigre, a black leather dye used to outline some of the works and cover mistakes, produced noxious fumes.

Subject matter was and is a perennial concern of the practicing velvet artist. If something sold, it would be repainted to sell again, and other artists took notice and copied the work.

How to Paint a Masterpiece

By JENNIFER "JUANITA" KENWORTH

What You Will Need:

- An image to paint
- Wooden stretcher bars (or preassembled stretcher frame)
- Black velvet fabric
- Staple gun
- Acrylic paints
- Painter's palette
- Selection of brushes
- Container for water
- Rag for cleaning brushes

1. **Select an image that is high-contrast.**
Images with lots of dark areas will allow the black velvet of the canvas to show through.

2. **Choose a size for your painting relative to your subject.**
Stretcher bars come in an array of shapes and sizes. Consider the scale and the effect of the painting you want to achieve.

3. **Build your canvas.**
I buy my velvet at fabric stores. Velvet with a dense pile (also usually more expensive) will hold the paint better and give you a more luxurious surface. Note that you'll need enough fabric to wrap around the

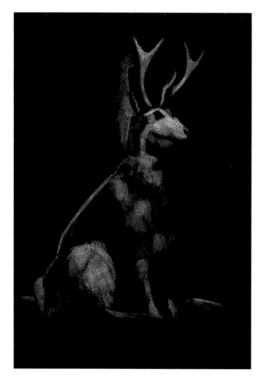

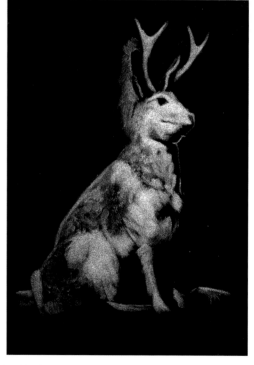

I begin painting with a layer of white paint, making a quick sketch and centering my image where I want it on the canvas. If I'm painting a portrait, I usually start with centering the nose, then paint indications for the eyes, the chin, hairline, etc. For the jackalope, I started with placement of the eye, head, antlers, and the points of the tail, haunch, and feet.

Once I've sketched an outline, I start adding color, which I build up by applying several thin layers of paint on the velvet to get a smooth surface. Loading too much paint on the brush can make the velvet fibers stick together and leave the surface lumpy. It's very important to remember not to paint the areas that are black, because those areas should be unpainted velvet.

stretcher bars to be tacked to the back. Once you have assembled the stretcher bar frame (fitting the tongue and groove pieces together), place your fabric velvet-side down on a flat surface and place the frame centered on top. Pull the canvas tight over the top bar of the frame and tack the velvet in place with the staple gun. Repeat for the bottom, left, and right sides of the canvas, folding the fabric at the corners and trimming the excess to give you a tight, clean painting surface on the other side.

4. Set up your paints.

I prefer acrylic paints because they are water soluble, dry quickly, and are easy to use. Oils paints take longer to dry, and you will need turpentine to clean your brushes. I also prefer to mix my own colors using the three primary colors (red, yellow, and blue), white, and black—from these I can blend any color I need.

5. Organize the rest of your supplies and start painting!

Jennifer "Juanita" Kenworth is an artist living in Portland, Oregon, who has been painting on velvet for over nine years.

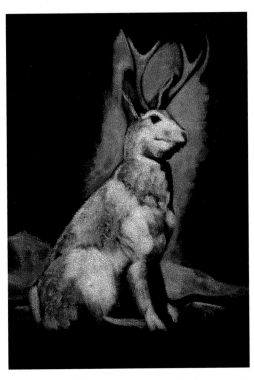

Add contrasting and bright colors to make the image really stand out. Light layers of paint will also help keep the tactile surface of the velvet present in the final painting where it's appropriate to your subject, for instance on the jackalope's fur.

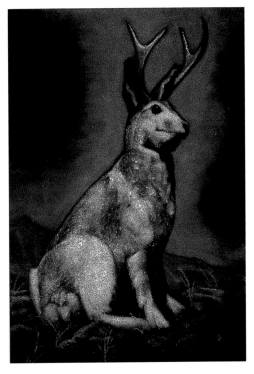

Keep painting until it's done, and don't forget to sign your name!

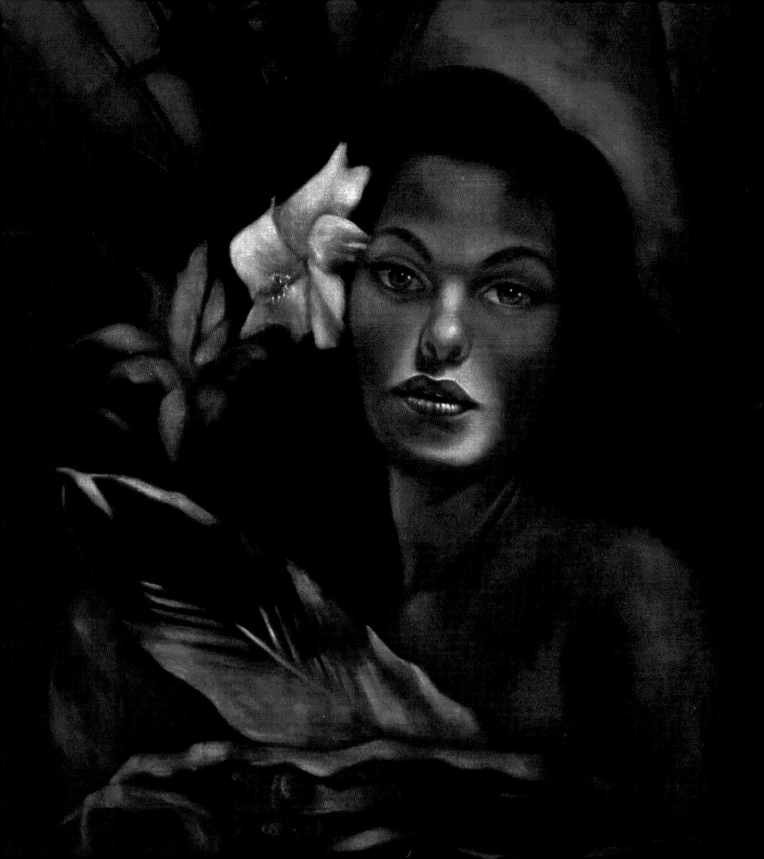

Polynesian Paradise

These are the lush green paradises where the pace of life is languid due to the tropical heat, and where the great masters of black velvet painting found their inspiration. Where women wear flowers behind their ears, where the world is on Island Time, and where on the Hawaiian isles "aloha" means *hello*, *good-bye*, and *I love you*, all in one.

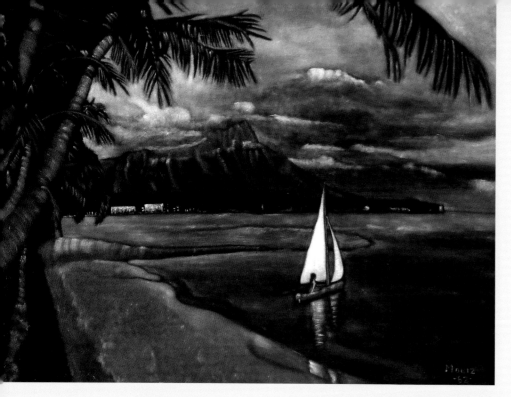

MONIZ
Diamond Head
1963

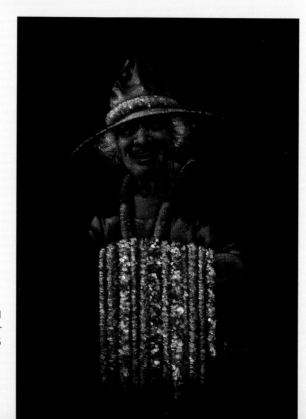

H.B. CHRISTIAN
Lei Seller
1936

AGULTO
Philippines
1960s

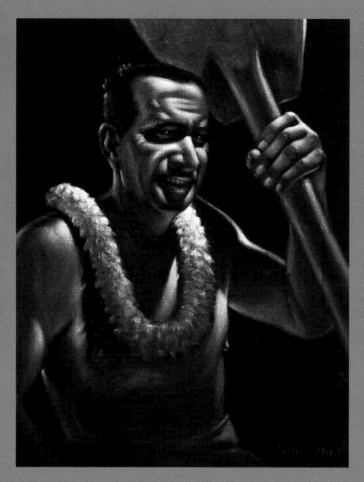

EKELAND
Untitled
1960s

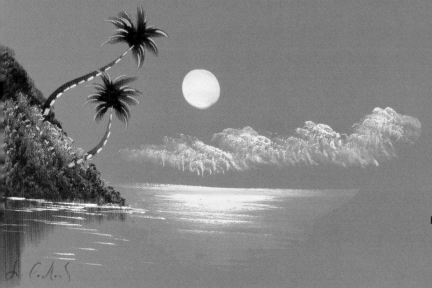

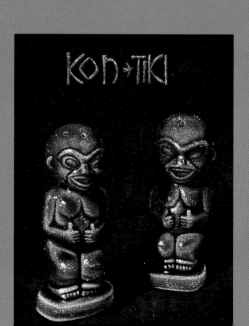

JENNIFER
"JUANITA"
KENWORTH
Kon Tiki
2007

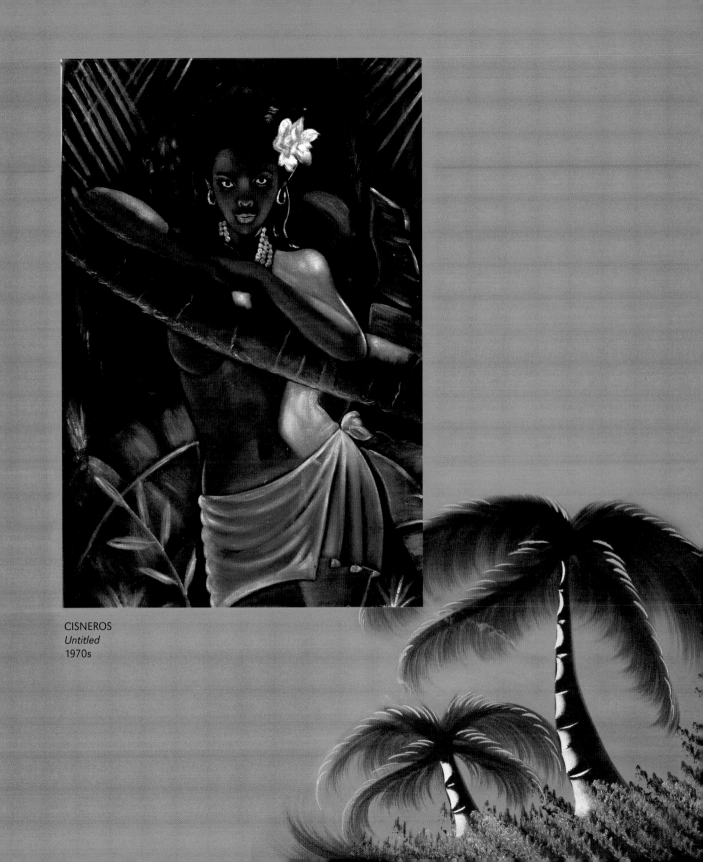

CISNEROS
Untitled
1970s

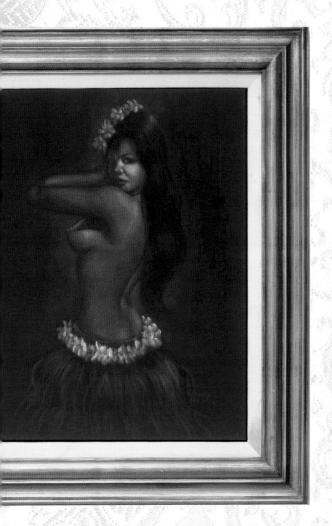

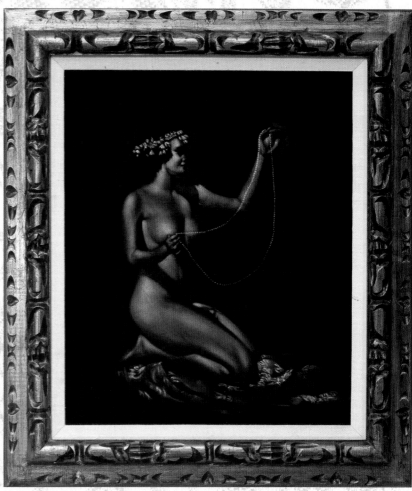

ALL
CECELIA RODRIGUEZ
Untitled
Early 1970s

50

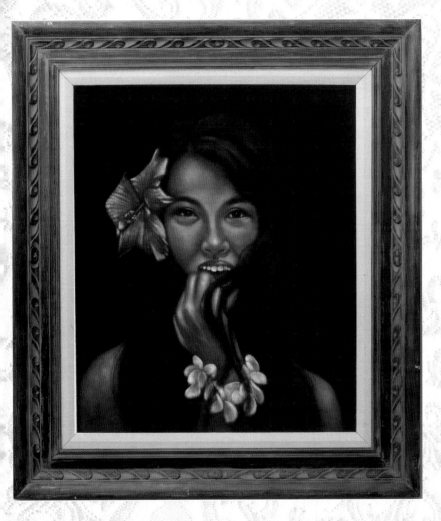

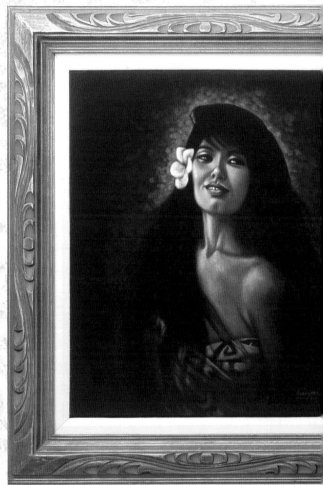

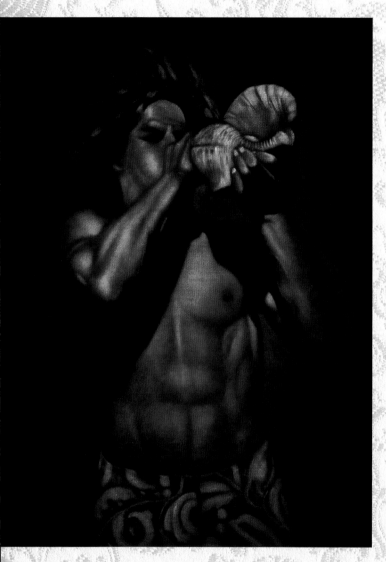

CECELIA RODRIGUEZ
After Leeteg's *Conch Shell Blower*
1970s

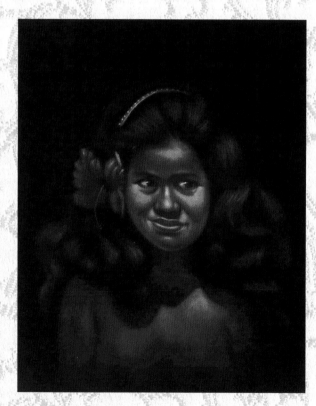

CECELIA RODRIGUEZ
Untitled
1970s

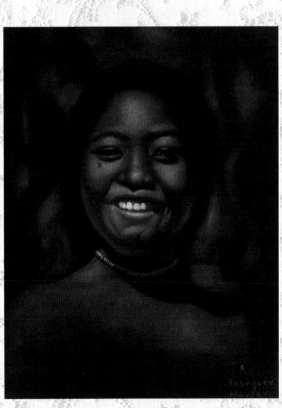

CECELIA RODRIGUEZ
Untitled
1970s

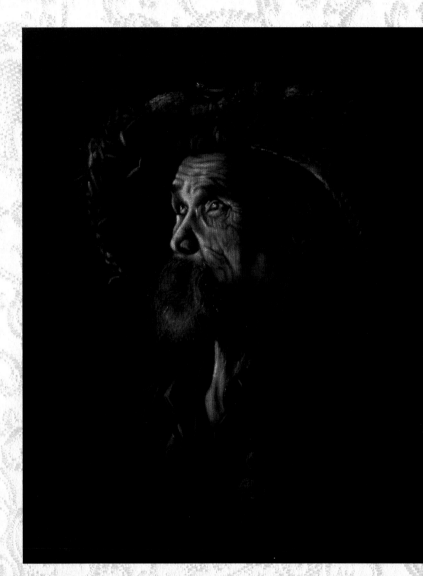

CECELIA RODRIGUEZ
Macecau
1970s
Macecau lived in Oahu,
and when he would walk by
Rodriguez painting images
of him, he would demand,
"Mama, you pay me!"

53

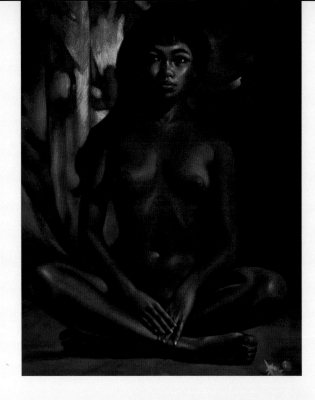

BURKE TYREE
Samea Samoan Girl
1974

BURKE TYREE
Pilisi
1965

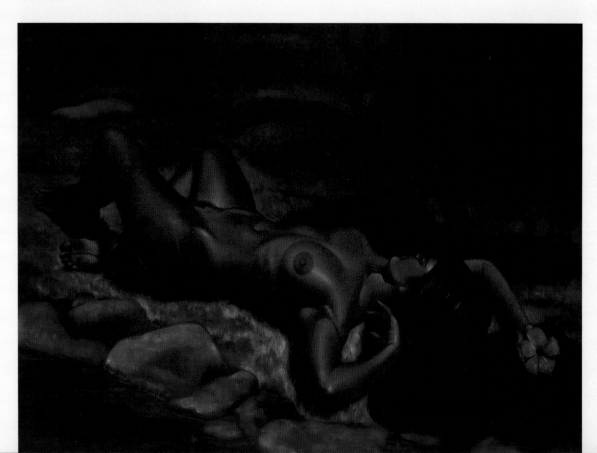

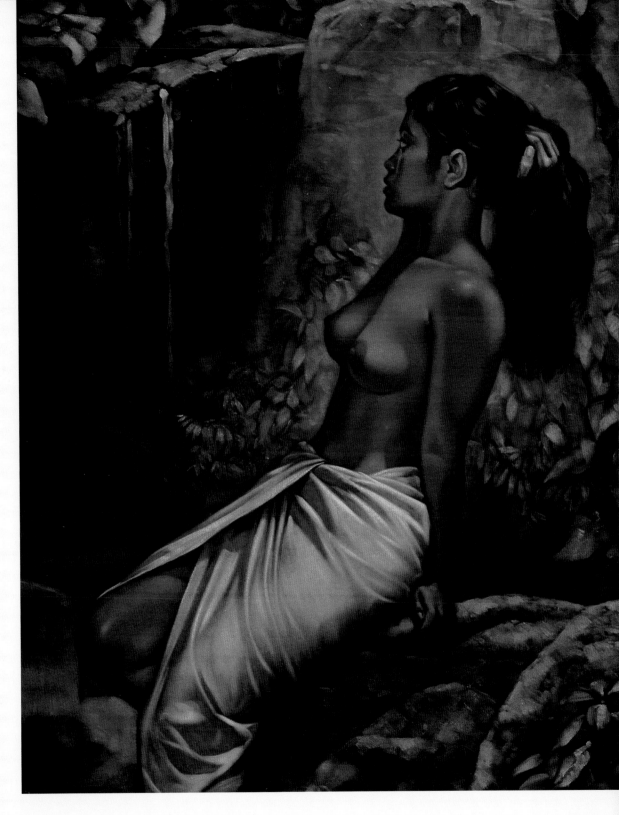

BURKE TYREE
Rora
1974

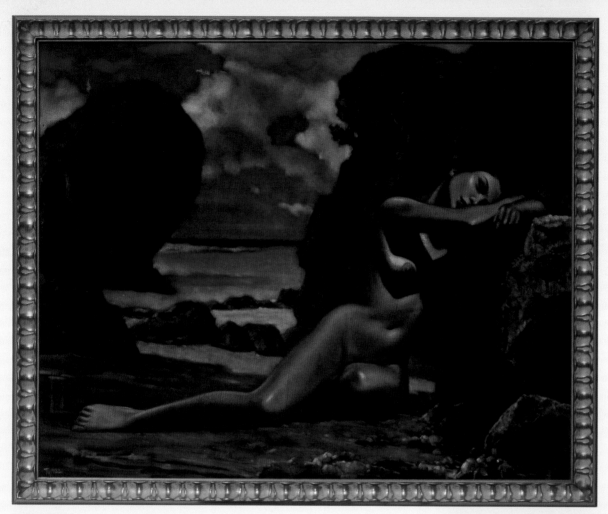

BURKE TYREE
Taelo
1971

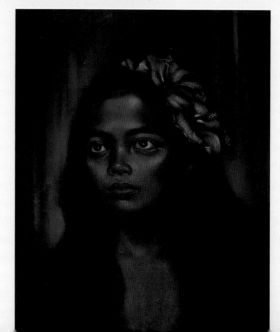

BURKE TYREE
Linea
1974

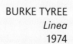

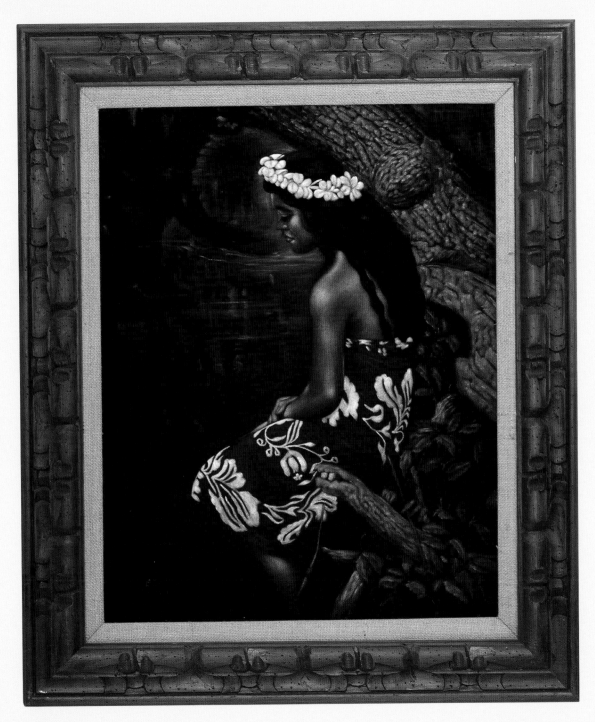

BILL ERWIN
Untitled
1970s
According to Dr. Kitch, Erwin considered
this painting his masterpiece.

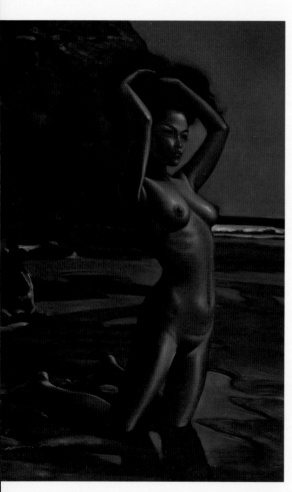

BURKE TYREE
Leonia
1973

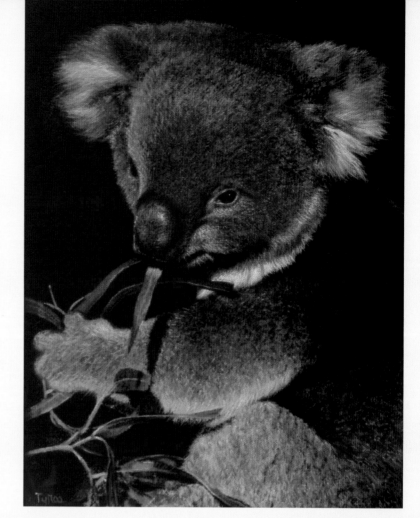

BURKE TYREE
Koala
1975

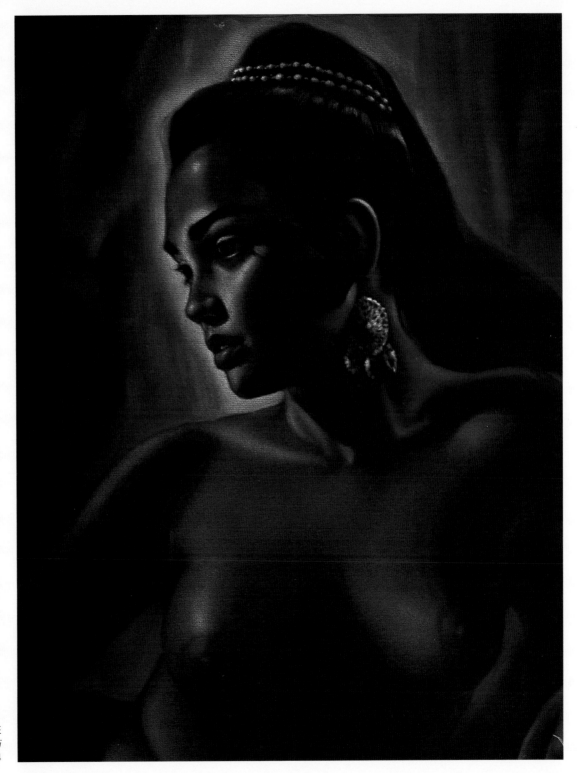

BURKE TYREE
Pilisi
1974

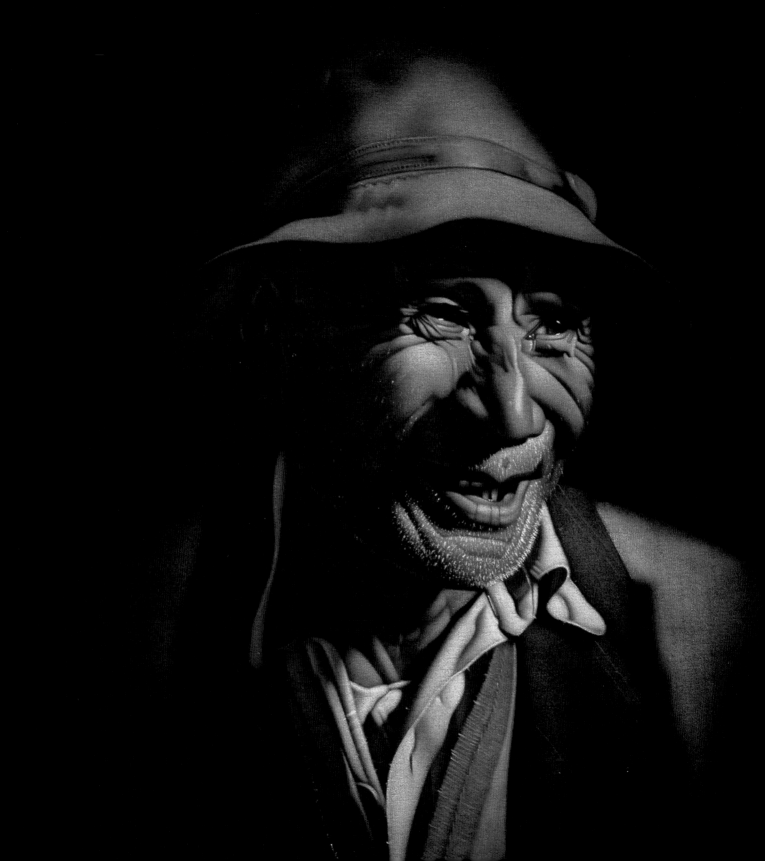

CHARLES McPHEE
A Maori Joke
Date unknown

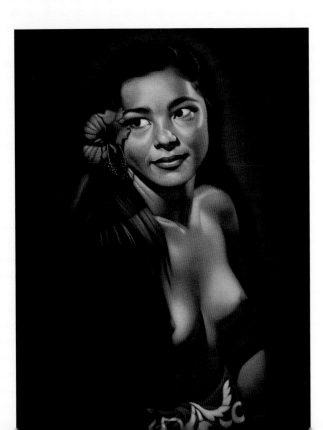

CHARLES McPHEE
Le Belle de Tahiti
Date unknown

CHARLES McPHEE
Elizabeth of Tahiti
Date unknown

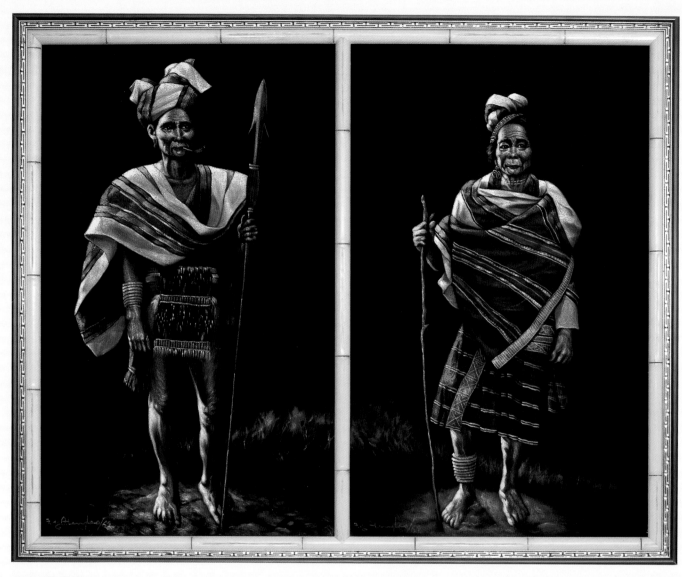

FELIX TANGLAO
Untitled
1963

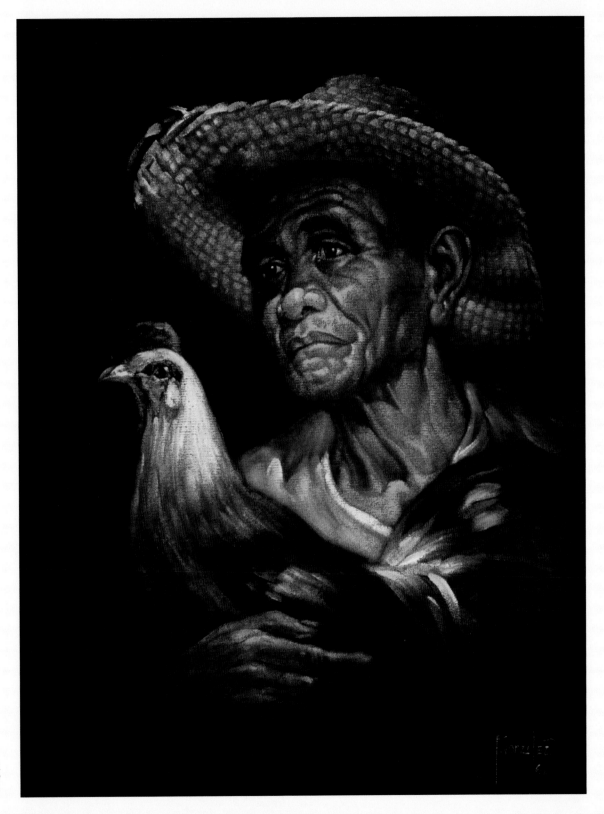

F. GONZALEZ
Untitled
1962

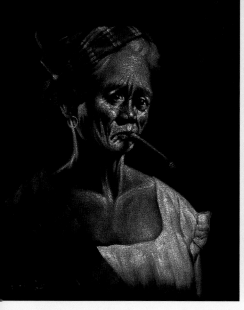

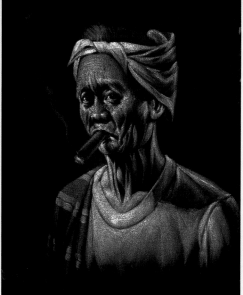

ENER
Man and Wife
1960s

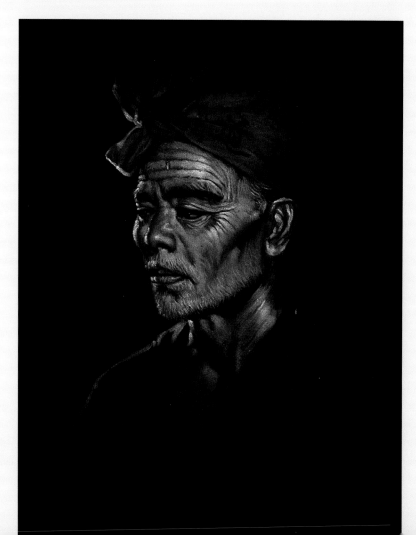

YONAHA
Untitled
1970s

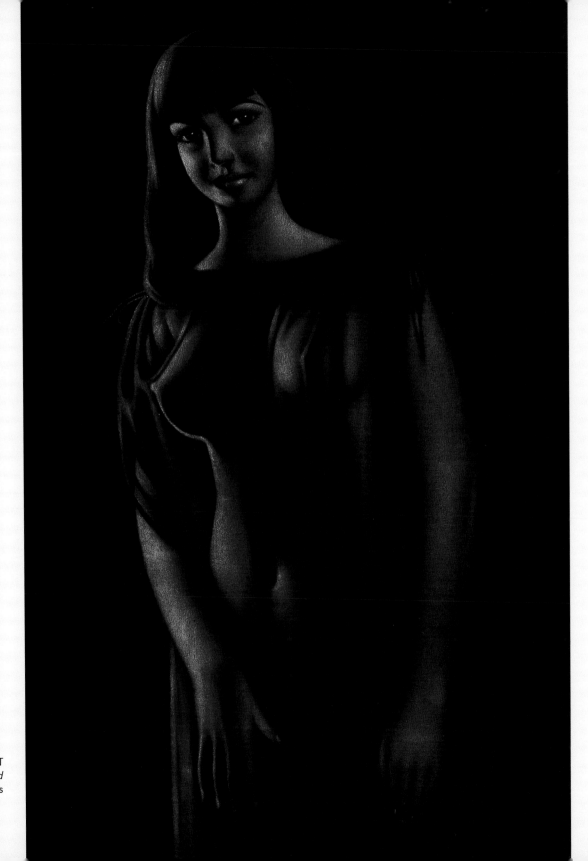

NICART
Untitled
Late 1960s

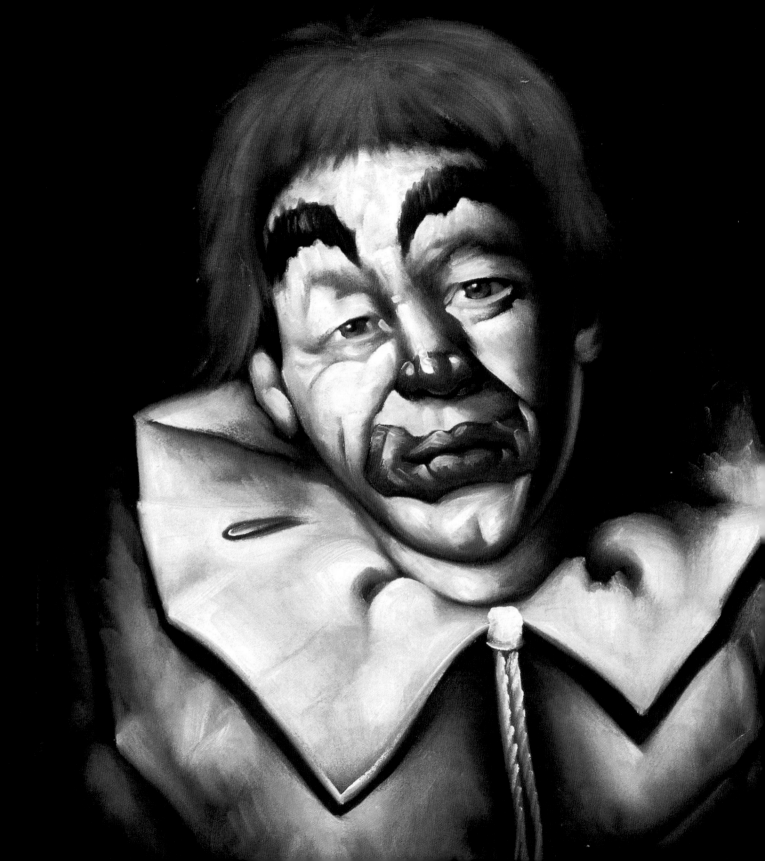

2 Clowntacular

Like the tears of a clown, when there's no one around.
— Smokey Robinson

Clowns. From the hobo jungle to the big top . . . why so much crying? Are they crying because it is so hot under the big top? Did their little dog die? Did the love of their life, the sequined and shapely-calved trapeze artist with a hint of a moustache, run off with the Leopard Man? Are clowns miserable, sentimental, misunderstood, blubbering fools, or do they know something we don't know?

LEFT: ARTIST UNKNOWN, *Untitled*, 1970s

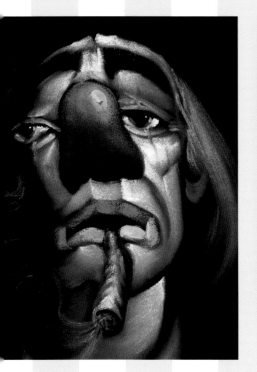

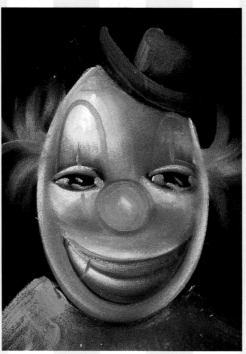

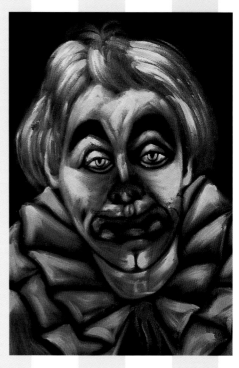

C.B.
Weary
1970s

BILL
Untitled
1980s

ARTIST UNKNOWN
Untitled
1970s

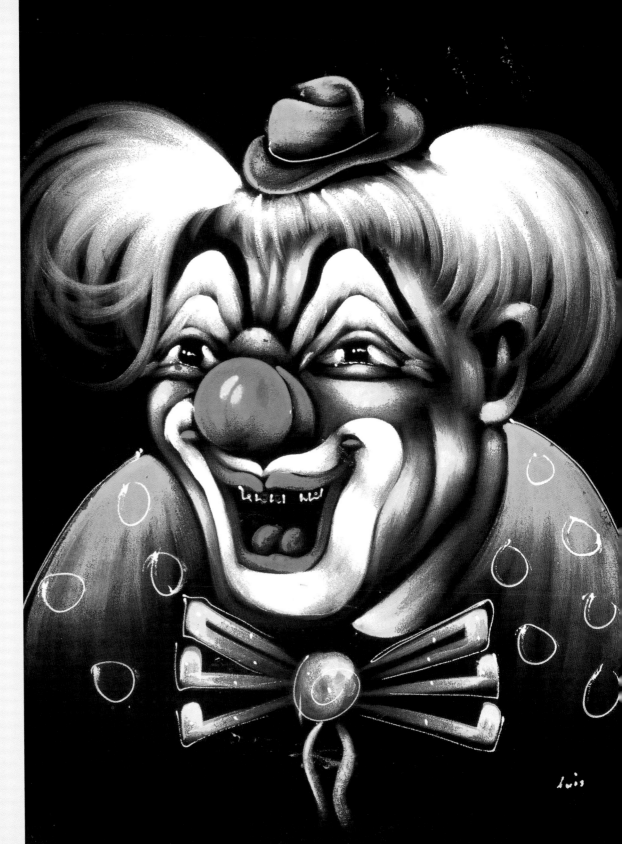

LUIS
Untitled
1970s

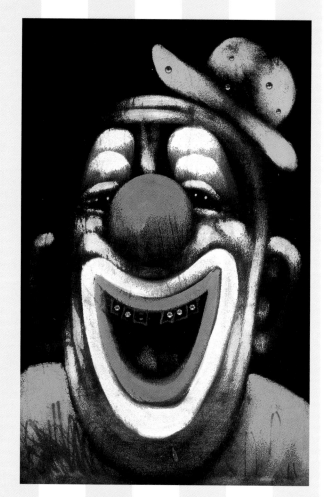

ARTIST UNKNOWN
Untitled
1970s

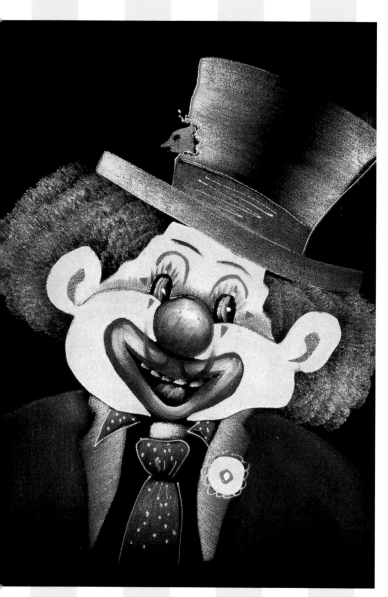

VELA
Untitled
1980s

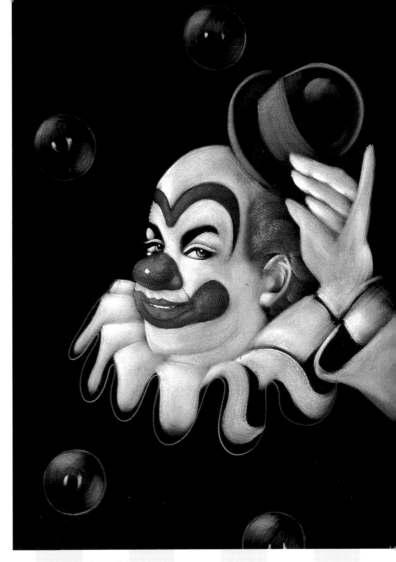

ARTIST UNKNOWN
Untitled
1970s

ARTIST UNKNOWN
She Loves Me. She Loves Me Not.
1970s

DIAZ
Carnival Monkey Love
1970s

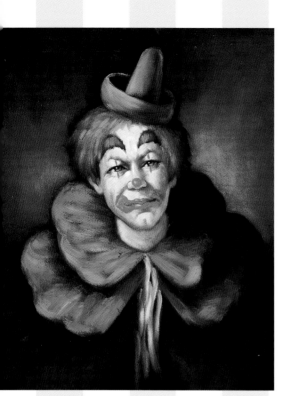

ARTIST UNKNOWN
Untitled
1970s

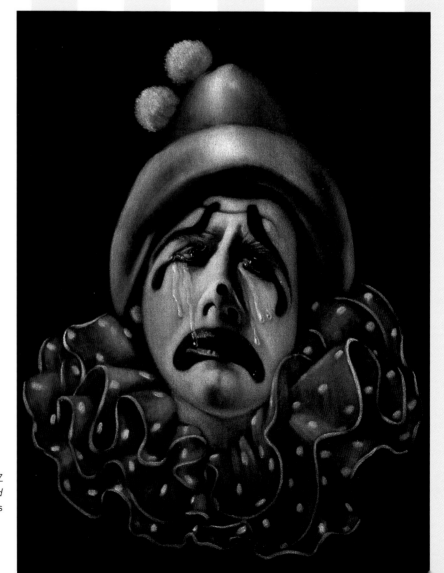

CECELIA RODRIGUEZ
Untitled
1960s

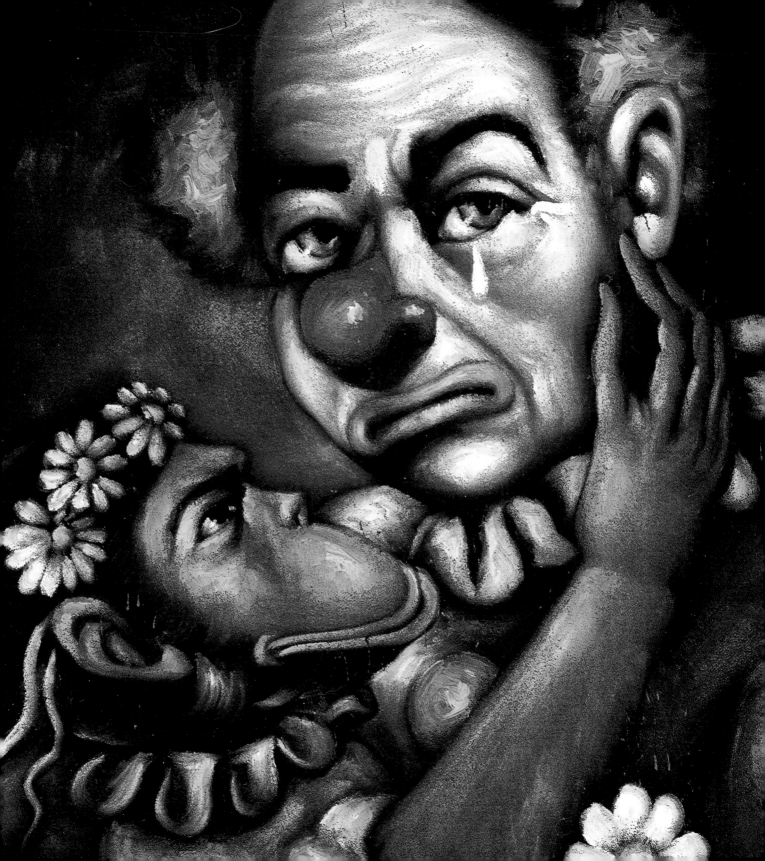

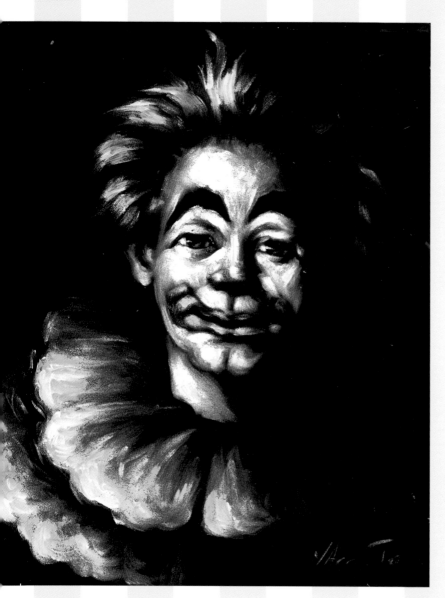

ARTIST UNKNOWN
Untitled, Maroon velvet
1970s

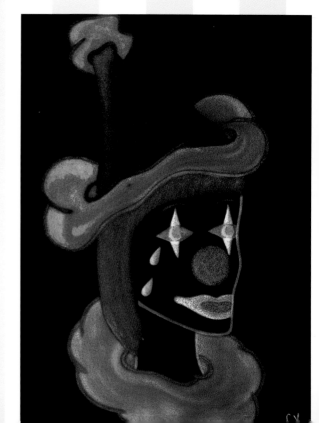

C.K.
Crying
1980s

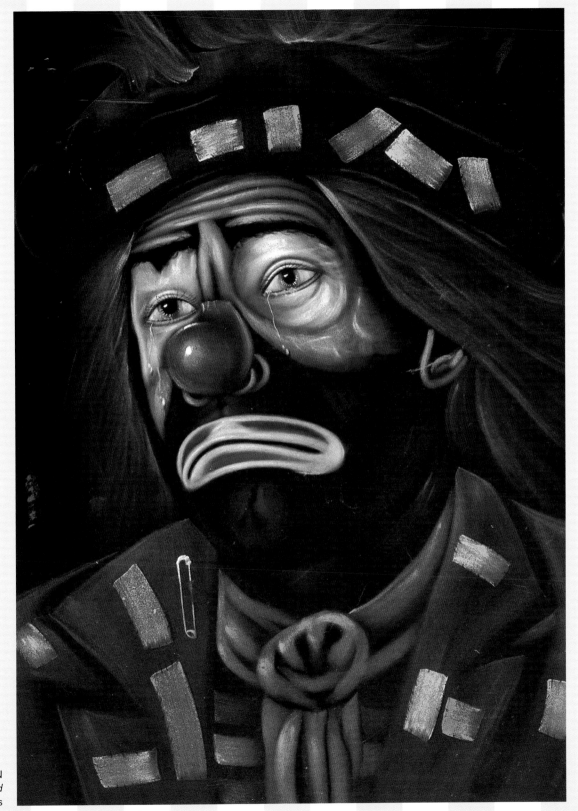

ARTIST UNKNOWN
Untitled
1970s

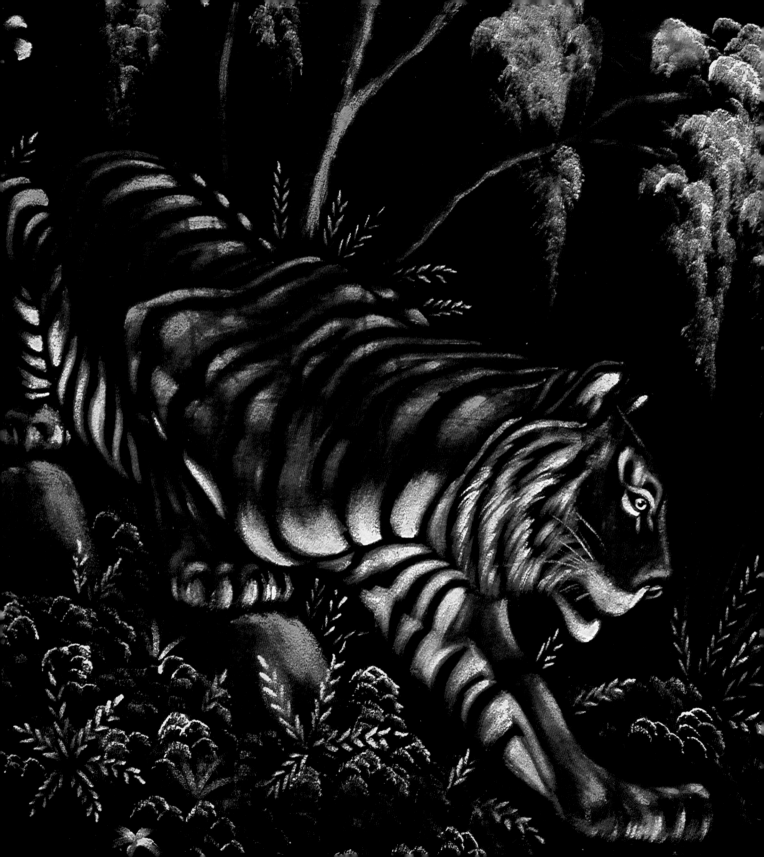

 # Creaturama

Horses frolic out of the sea . . . sea horses. Unicorns bask in cheery glades,
awaiting the approach of virgins so they can fall asleep in the ladies' laps.
Big cats rule. Pink poodles and pit bulls live in harmony, and thrive, while the
hounds deal from the bottom of the deck and take you for all you're worth.

LEFT: POGETTO, *Tiger*, 1970s

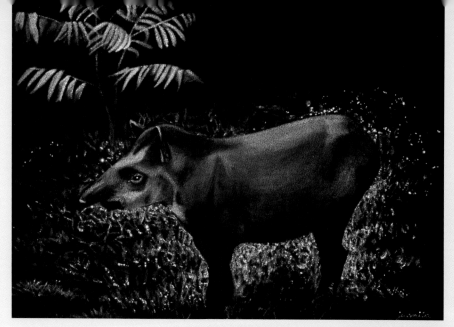

JENNIFER "JUANITA"
KENWORTH
Tapir
2007

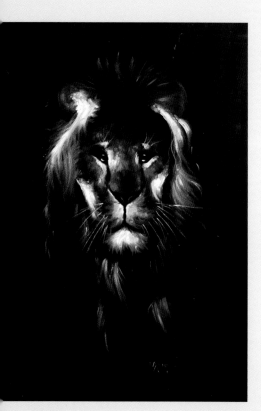

ARTIST UNKNOWN
Untitled
Date unknown

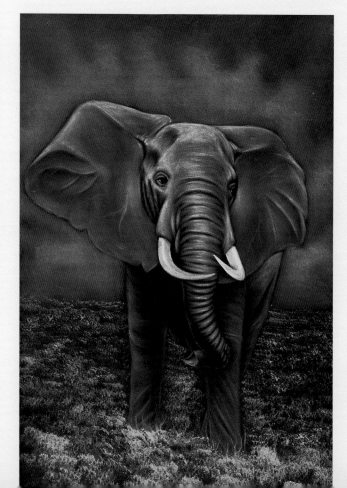

ARTIST UNKNOWN
Untitled
1970s

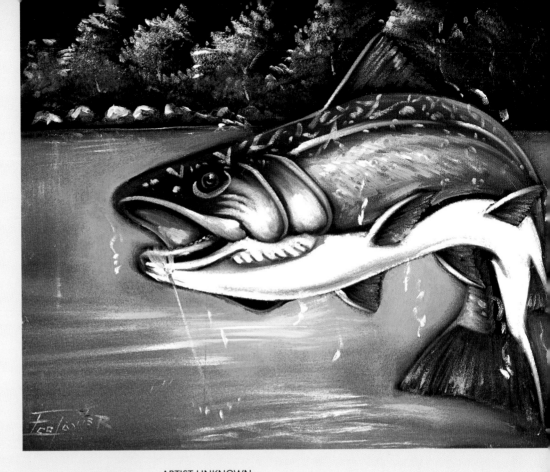

ARTIST UNKNOWN
Big Mouth Bass
Date unknown

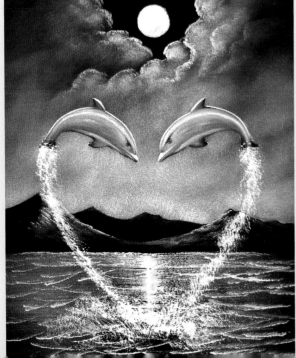

TOM
Dolphin Love
2007

79

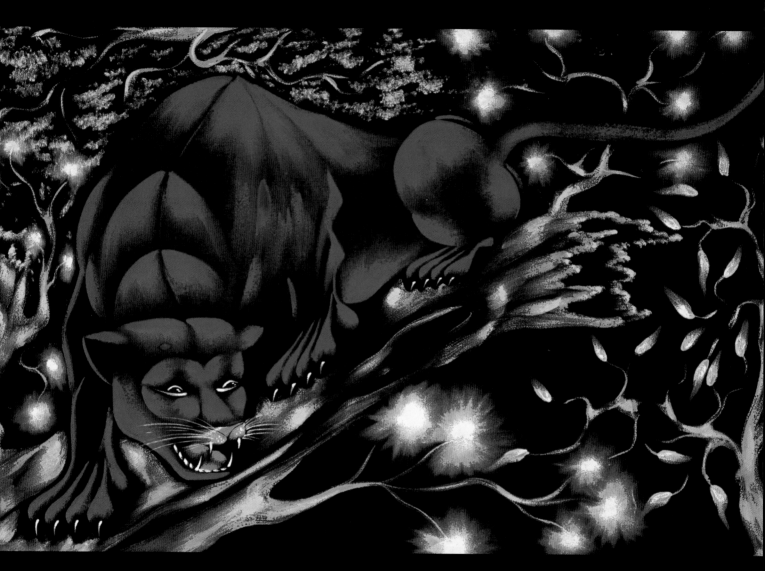

ARTIST UNKNOWN
Blue Panther
Late 1970s

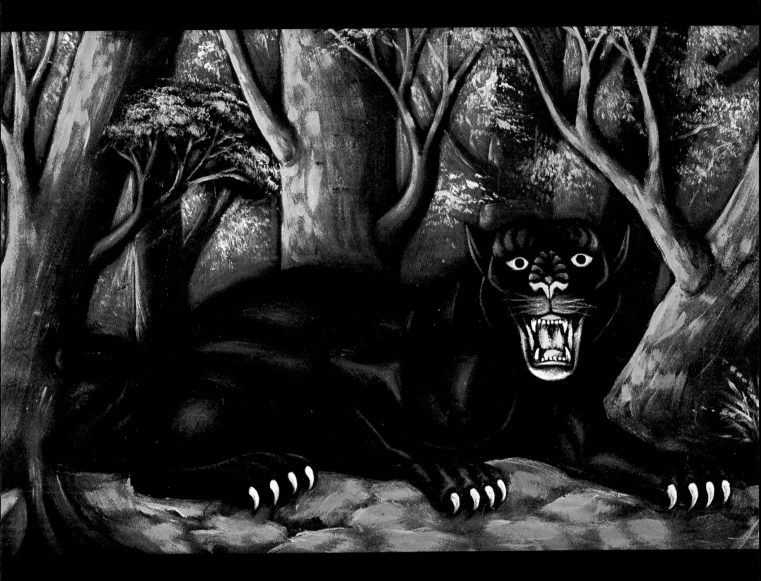

AGULTO
Black Panther
1970s

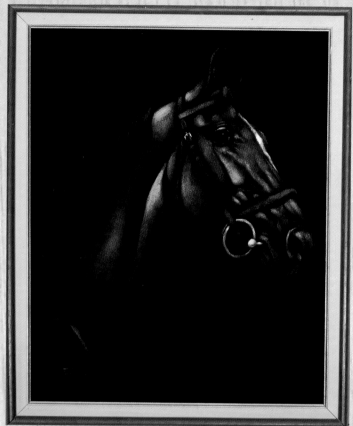

PATTO
Horse 1
1970s

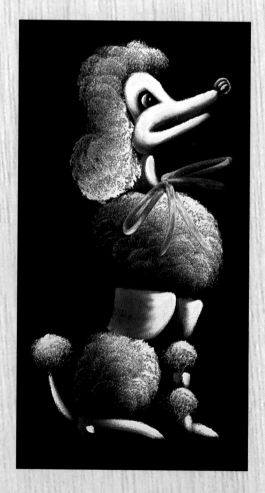

ARTIST UNKNOWN
Les Fifis (pair)
1960s

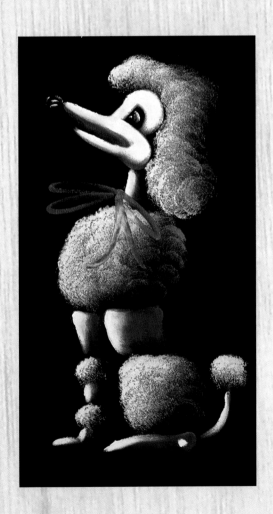

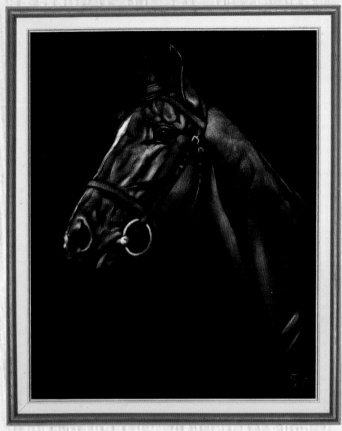

PATTO
Horse 2
1970s

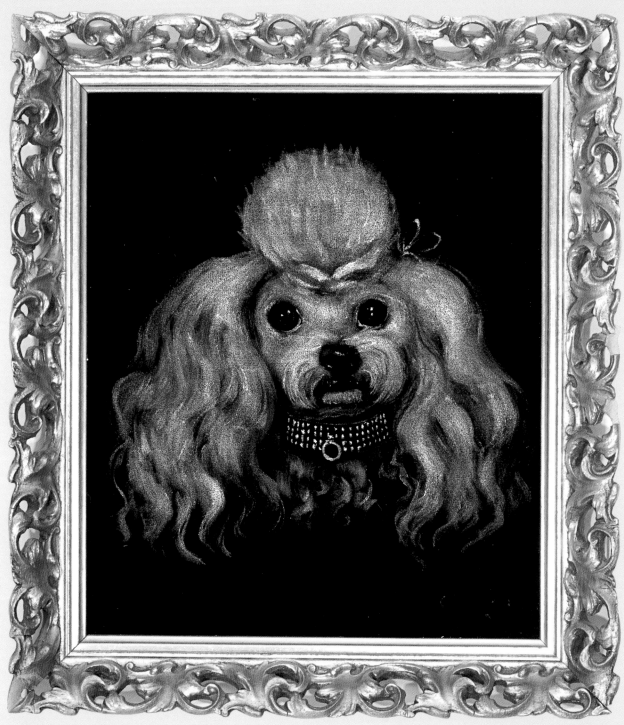

CECELIA RODRIGUEZ
Poodle
1970s

ABOVE
BILL ERWIN
Untitled
1970s

ABOVE RIGHT
BILL ERWIN
Untitled
1970s

RIGHT
CECELIA RODRIGUEZ
Pup in a Cup
1970s

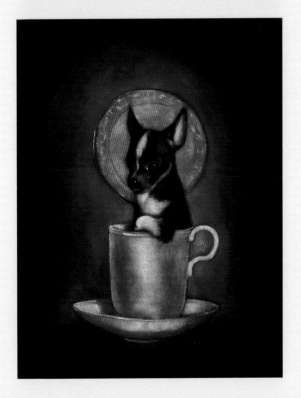

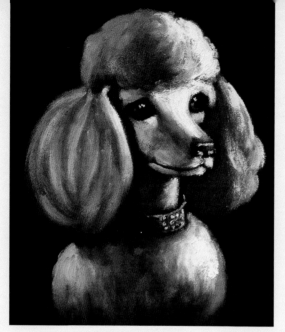

ESPINOZA
June Cleaver
1970s

ORTIZ
Untitled
2006

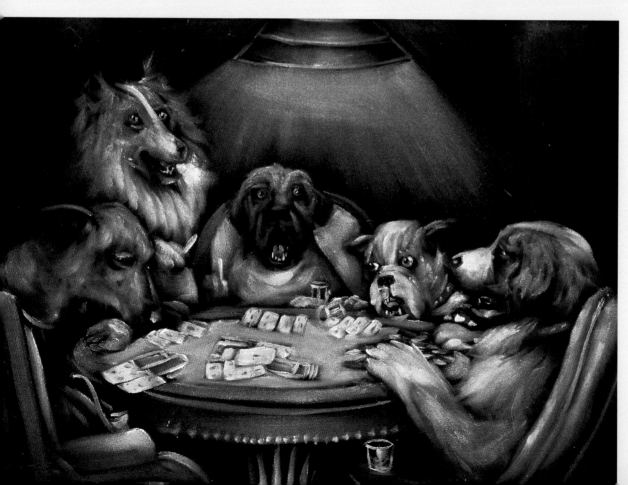

ARTIST UNKNOWN
Dogs Playing Poker
2001

DENNIS G.
ANDERSON
Lee Marvin
1983

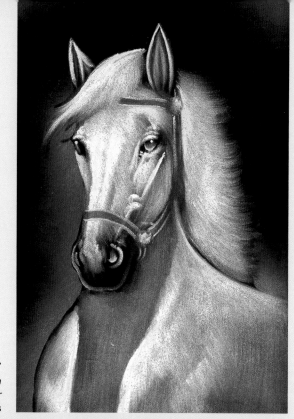

"B"
*Horse with
Farrah Fawcett Hair*
1980s

ARTIST
UNKNOWN
Untitled
1970s

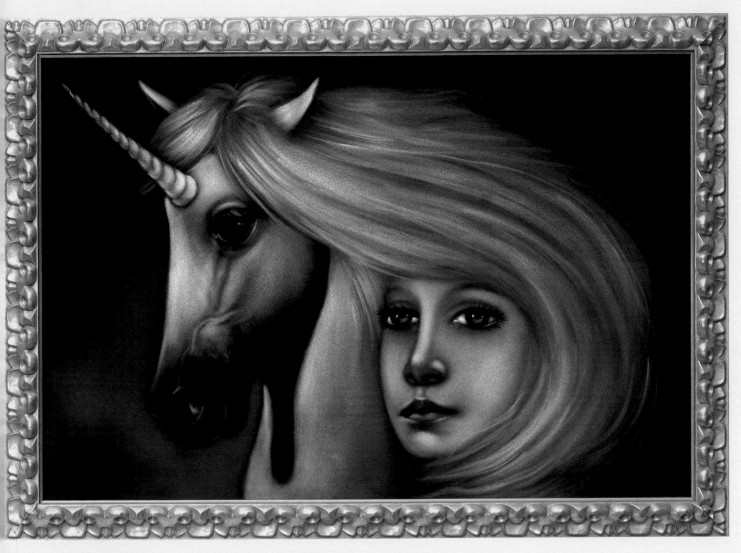

ARTIST UNKNOWN
Untitled
Late 1980s

ARTIST UNKNOWN
Untitled, Beige velvet
Date unknown

ARTIST UNKNOWN
True Love
1980s

AREOLA
Seahorses
Late 1970s

FAR LEFT
ARTIST UNKNOWN
Horn Lock
1980s

LEFT
ARTIST UNKNOWN
Conjoined
1980s

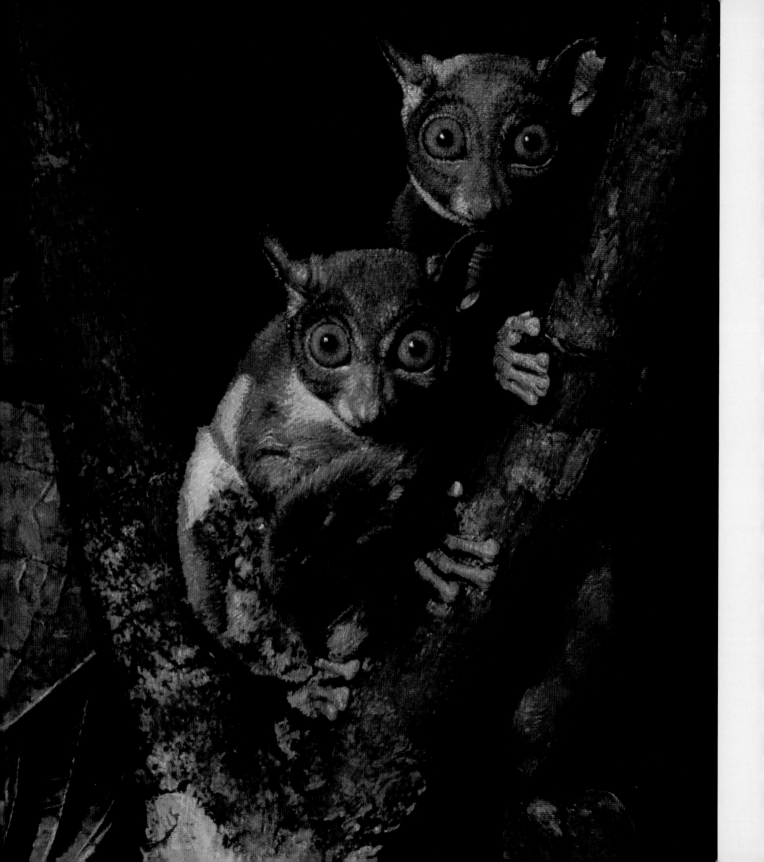

BILL ERWIN
Siamese Twins
1970s

BURKE TYREE
Dwarf Lemur
1975

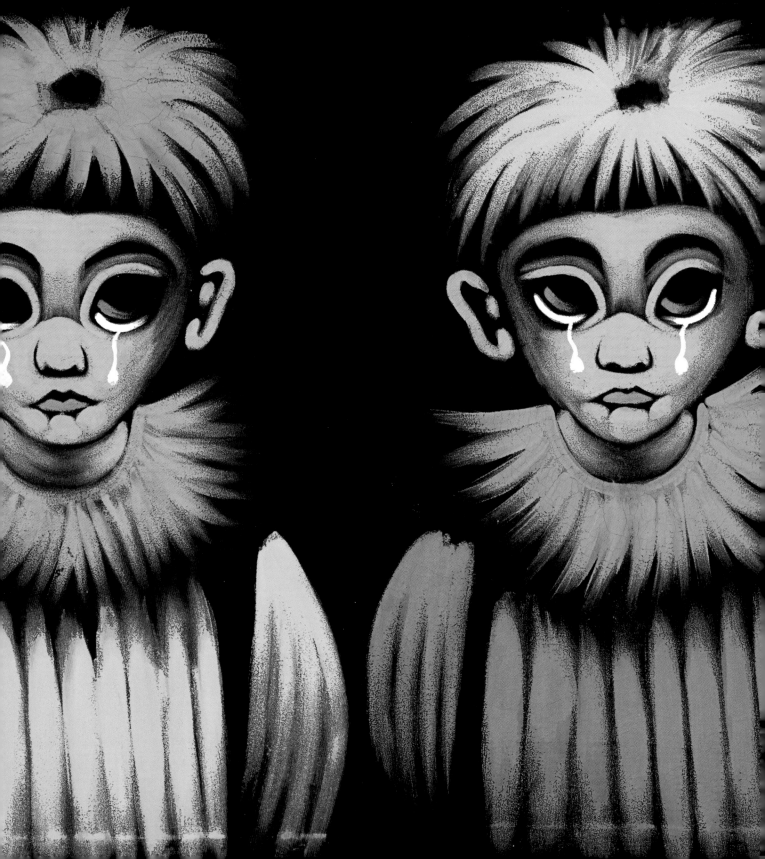

4 Big Eyes

Jeepers, creepers, where'd you get those eyes? Probably from Margaret Keane's terrifying but popular 1960s paintings of sad souls with abnormally large eyes. *Buy me, take me home, love me. Won't somebody love me?* Mexican painters took the tears to an even weirder place, the Land of the Big-Eyed Dog Children, many of whose lost children have bright blue hair and glow in the dark.

LEFT: ARTIST UNKNOWN, *Untitled*, Late 1970s

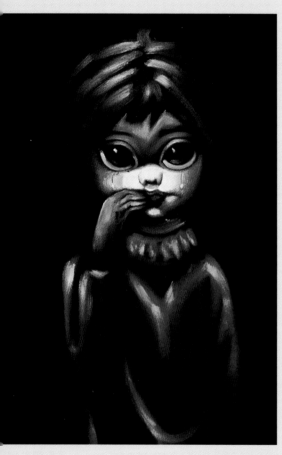

ROCHA
Untitled
1970s

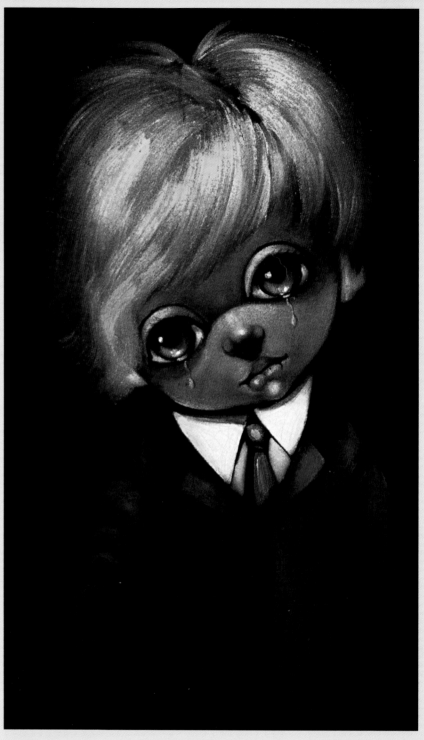

ARTIST UNKNOWN
Untitled
1970s

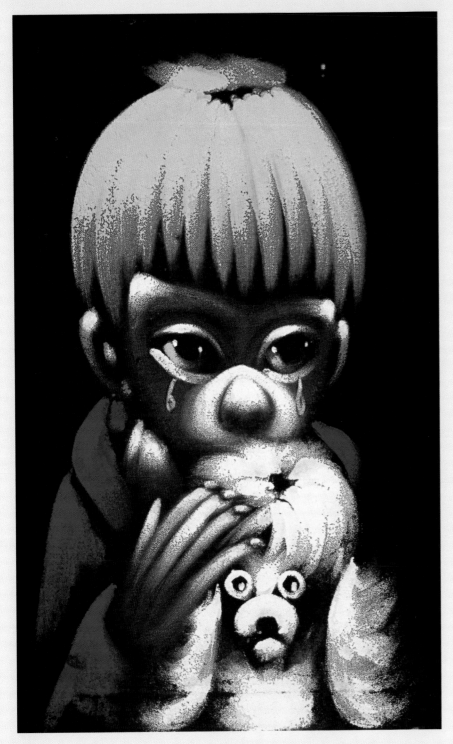

ARTIST UNKNOWN
Untitled
1970s

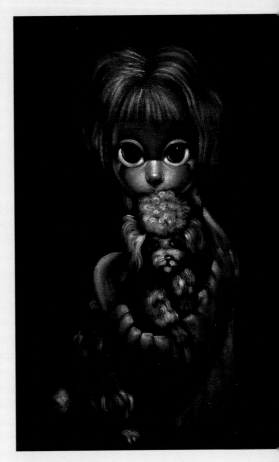

ARTIST UNKNOWN
Untitled
1970s

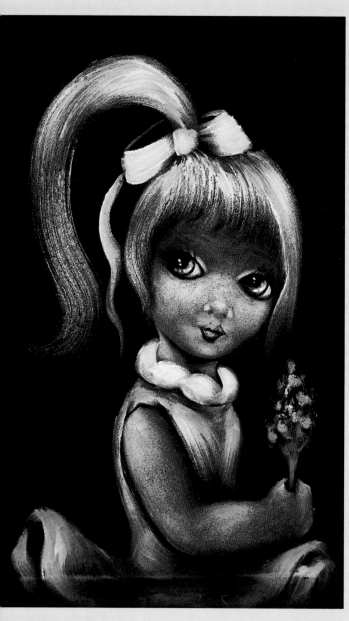

ARTIST UNKNOWN
Flower Child
1970s

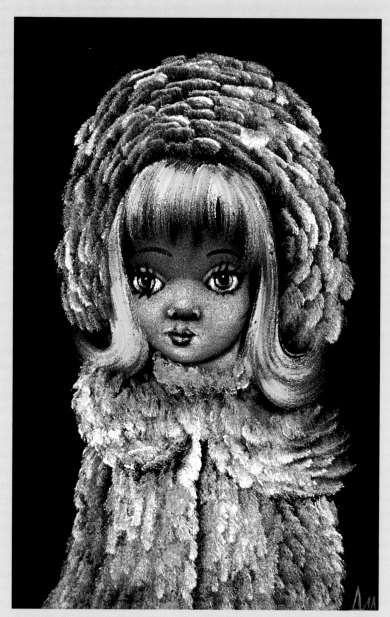

ARTIST UNKNOWN
Untitled
1970s

98

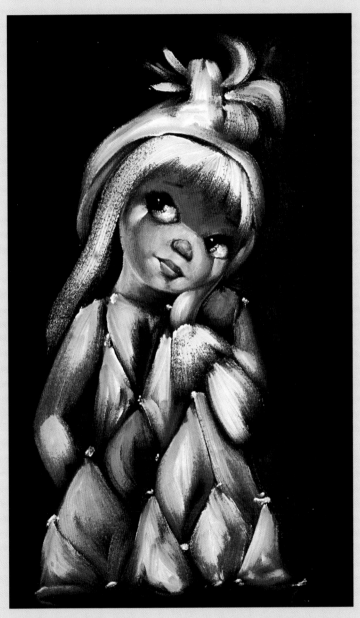

ARTIST UNKNOWN
Harlequin
1970s

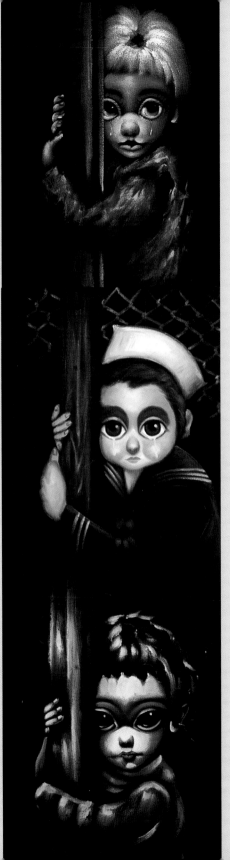

DANIEL
Untitled
1970s

FRANK ROCA
Sailor
1970s

FRANK ROCA
Untitled
1970s

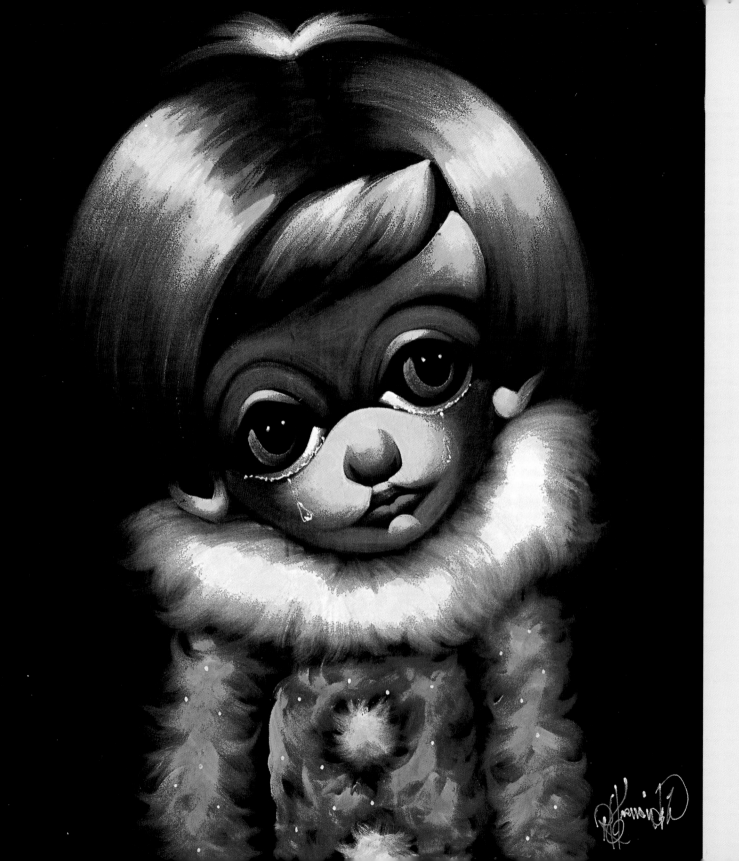

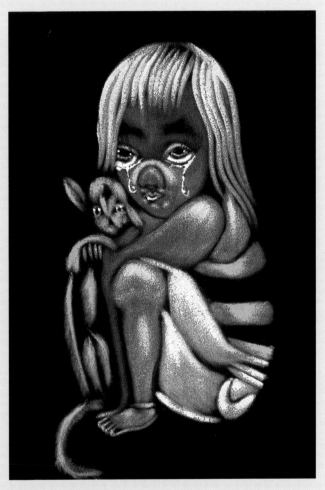

ARTIST UNKNOWN
Untitled
1970s

ARTIST UNKNOWN
Untitled, Blacklight painting
1970s

LEFT
ARTIST UNKNOWN
Untitled
1970s

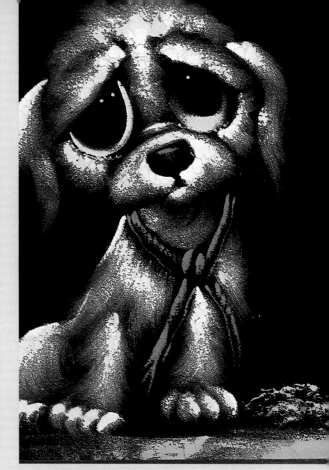

ARTIST UNKNOWN
Dog Trilogy
1970s

ARTIST UNKNOWN
Bambi
Early 1970s

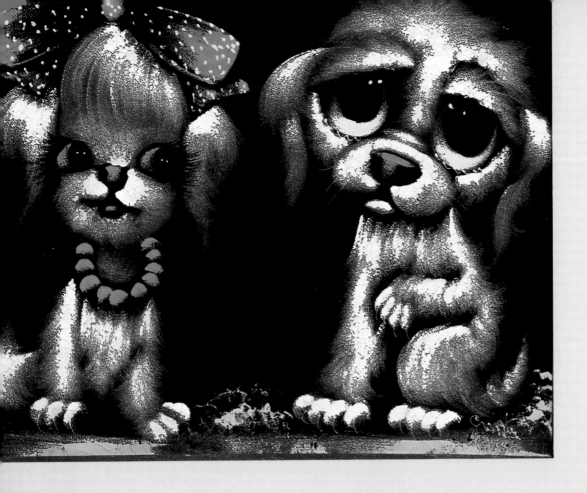

RIGHT
ARTIST UNKNOWN
Untitled
1970s

FAR RIGHT
ARTIST UNKNOWN
Potty Child
1970s

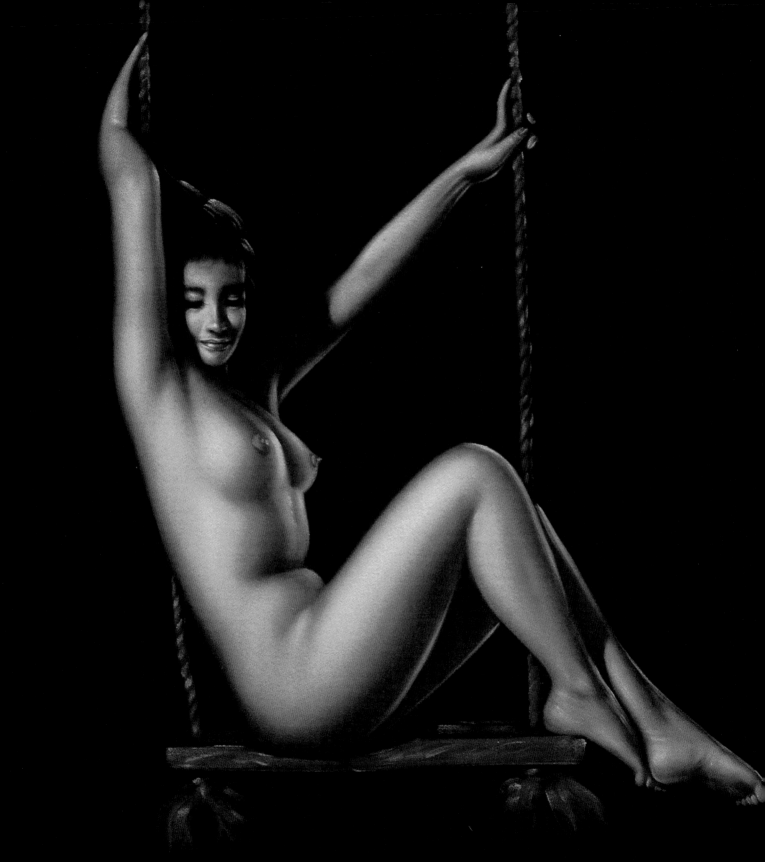

5 Nudes from Around the World

Black velvet is a magnet to the eye. The allure of black velvet plays on the senses. See, and you want to touch. The luminous glow of skin lures you in, inviting you to feel its power—a light out of the darkness, be it the stars in the sky or a woman coming out of the shadows toward the soft light of a candle, anticipating her touch, the exhilaration of the moment just before your lips meet and you fall together in a velvet crush.

LEFT: C.H. SHI, *Untitled,* 1970s

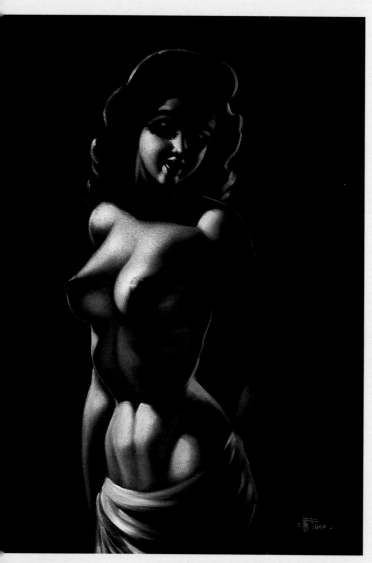

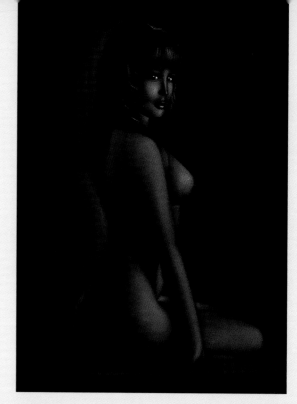

ZAZUELA
Redheaded Vixen
1970s

PEINA
Untitled
1960s

C.H. SHI
Sharon Tate (from the movie
Fearless Vampire Killers)
1967

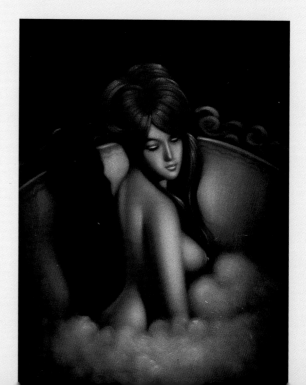

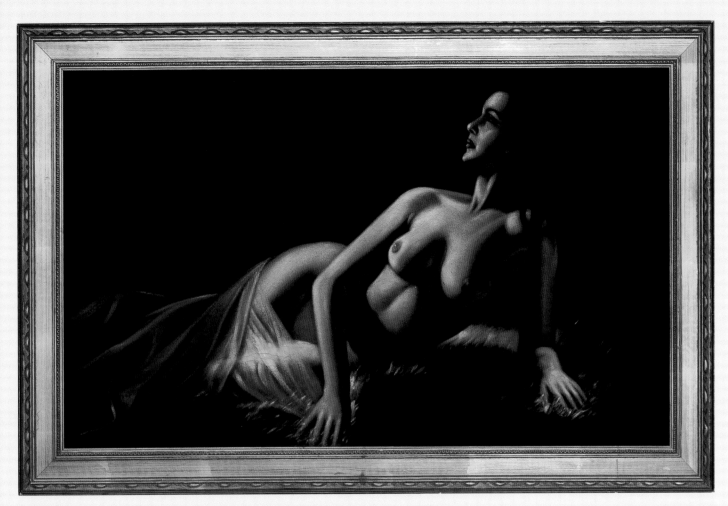

M. CASAÑAS
Untitled
1962

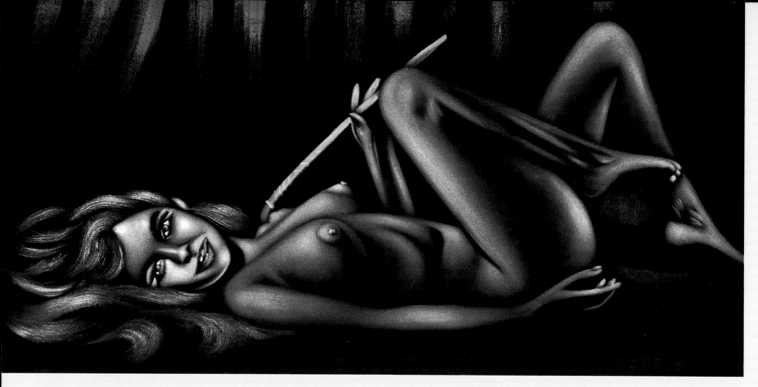

ARTIST UNKNOWN
Pinky
1970s

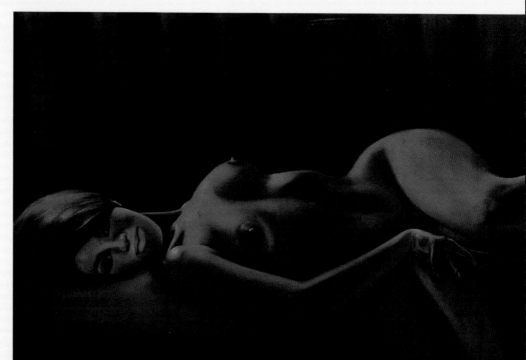

FELIX
Untitled
1970s

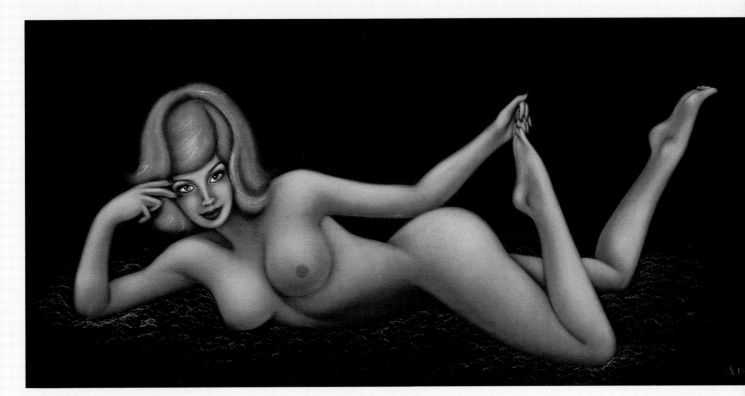

ARTIST UNKNOWN
Untitled
1970s, Mexico

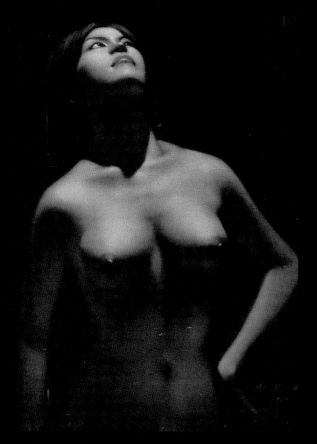

ARTIST UNKNOWN
Untitled
1967

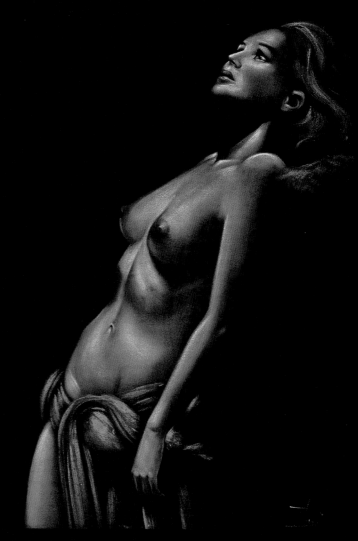

ARTIST UNKNOWN
Ursula Andress
1970s

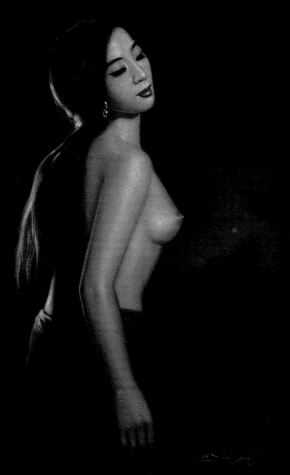

YONAHA
Untitled
1973

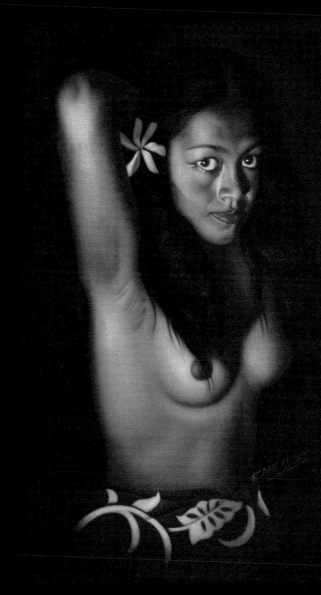

CHARLES McPHEE
Tahitian Innocence
Date unknown

RICHARD BUSTAMANTE
Legend Tempest Storm
2007

ARTIST UNKNOWN
Who's Next?
1970s

MARY
Untitled
1970s

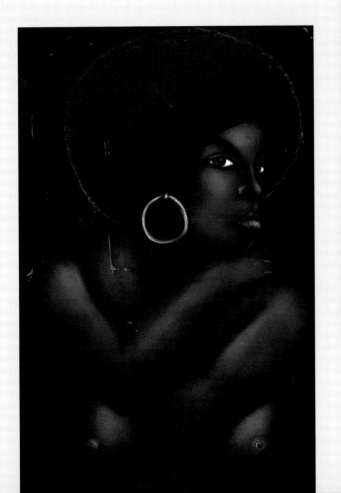

ARTIST UNKNOWN
Untitled
1970s

113

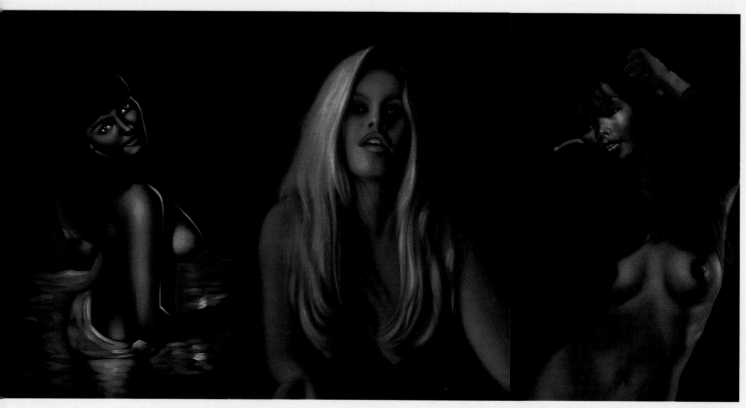

ZAZUELA
Barbi Benton
1970s

C.H. SHI
Brigitte Bardot
1970s

CECILIO
Untitled
1970s

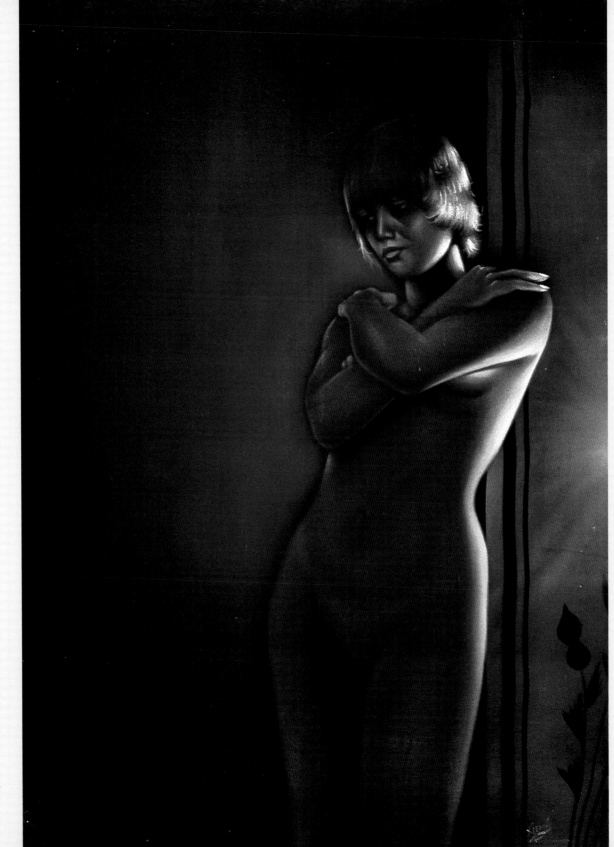

XENIA
Elke Sommer
1970s

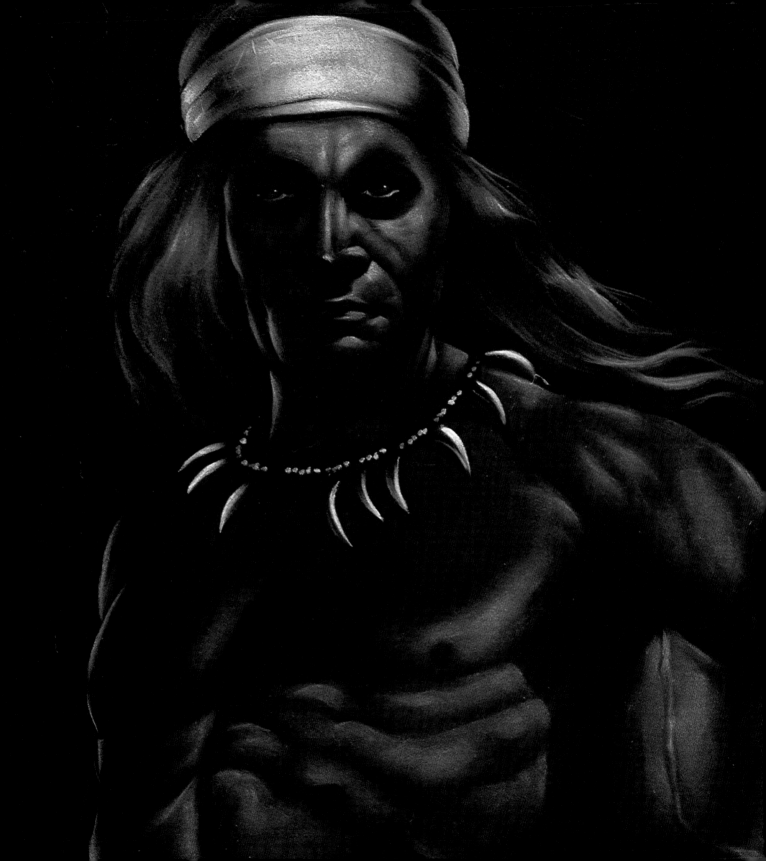

6 Wild West

The Wild West—where Clint Eastwood's Man With No Name squints through the dust, Charles Bronson's steely-eyed stare cuts through the glare, and John Wayne's big fist always settles the score. Banditos, with no stinking badges, appear out of nowhere to steal your horse, your boots, maybe everything, gringo. The Ancient One looks down from the mesa and watches the sun set on the end of the trail.

LEFT: ARTIST UNKNOWN, *Untitled,* 1970s

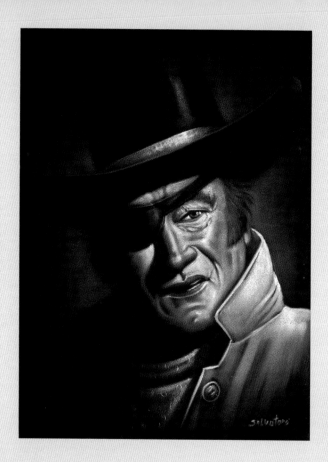

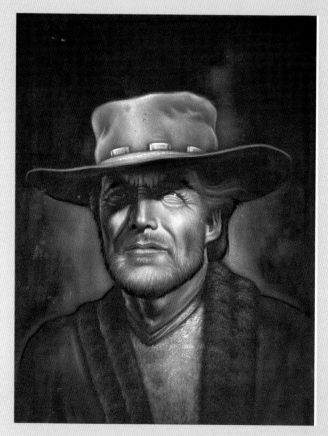

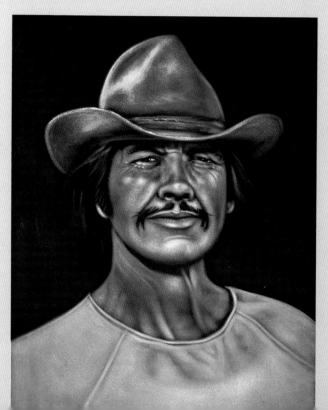

ABOVE
SALVATORE
The Duke
1970s

ABOVE RIGHT
ARTIST UNKNOWN
Clint Eastwood
1970s

RIGHT
ARGO
Charles Bronson
2001

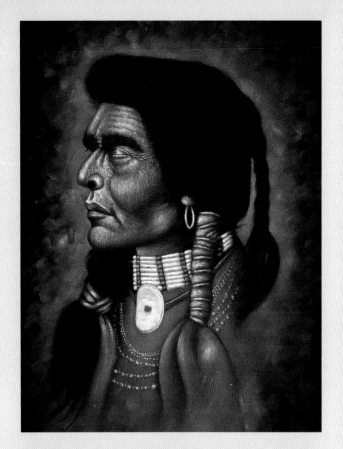

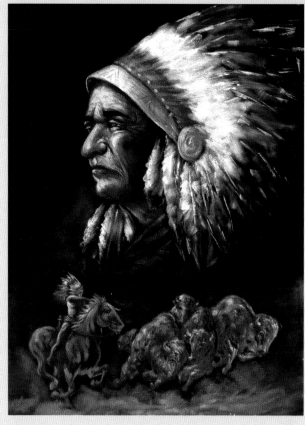

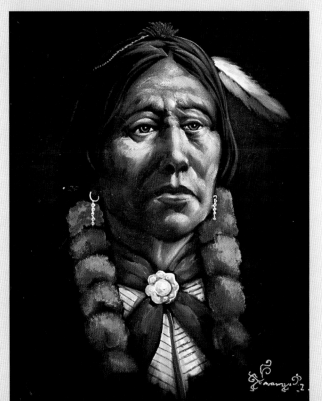

ABOVE LEFT
ARTIST UNKNOWN
Untitled
1970s

ABOVE
ARTIST UNKNOWN
Untitled
1970s

LEFT
MORAN
Untitled
1980s

119

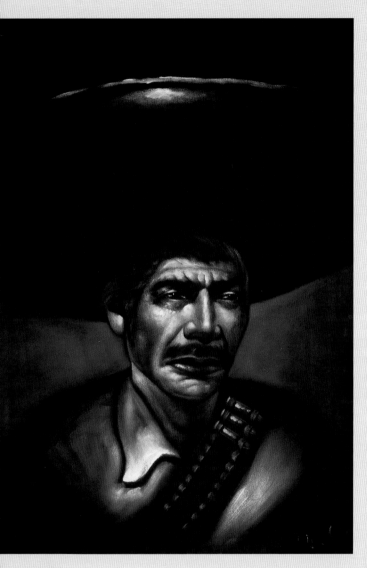

FLORES
Lee Van Cleef
1970s

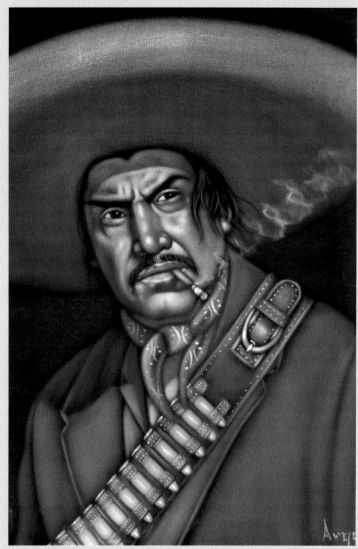

ARGO
Emilio Fernandez ("El Indio")
2000

120

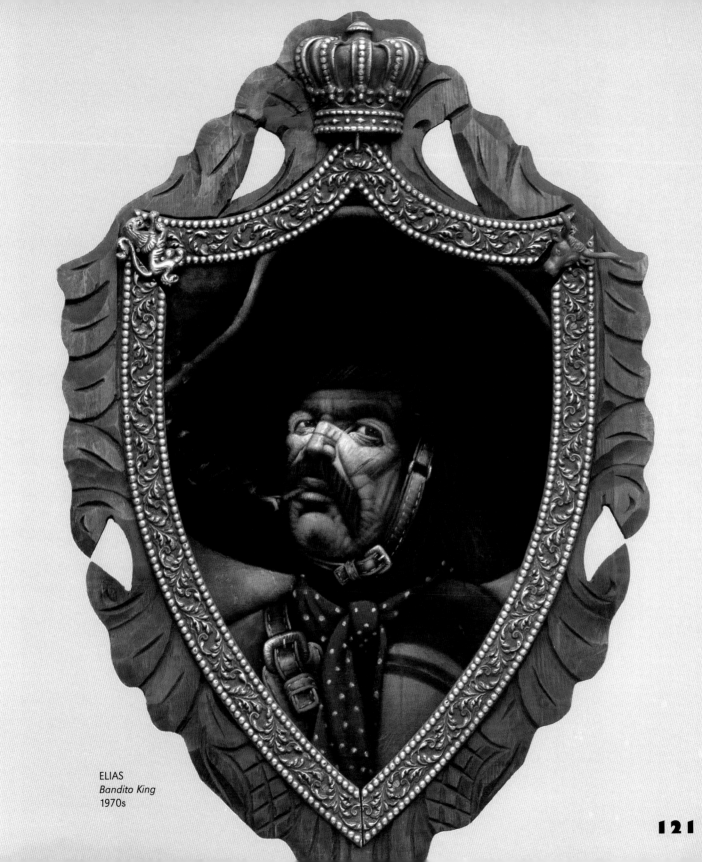

ELIAS
Bandito King
1970s

121

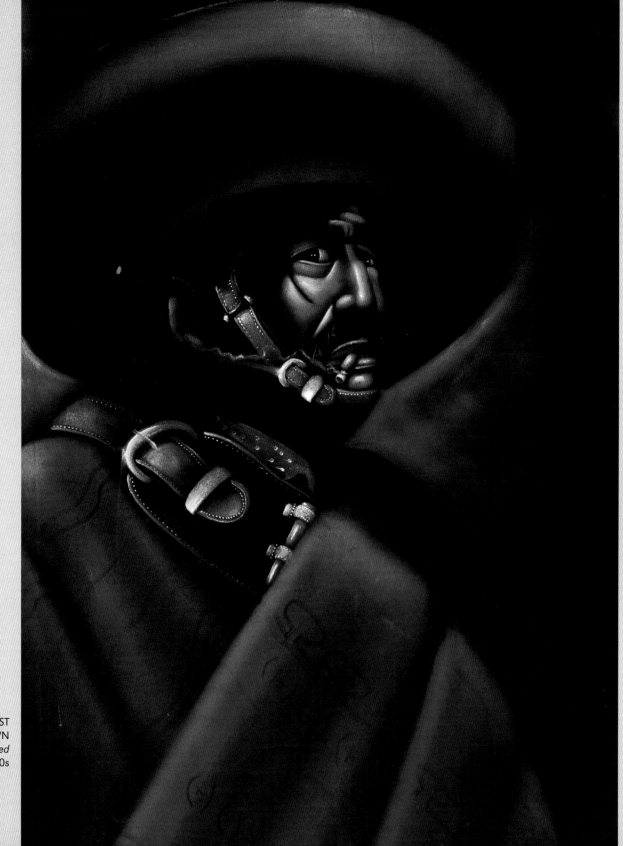

ARTIST
UNKNOWN
Untitled
1970s

122

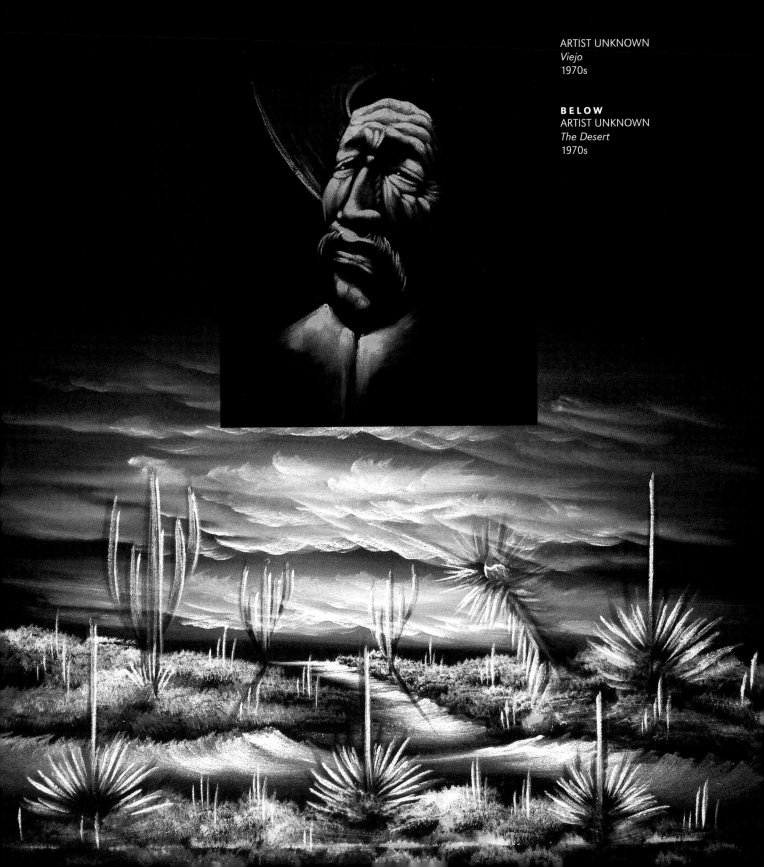

ARTIST UNKNOWN
Viejo
1970s

BELOW
ARTIST UNKNOWN
The Desert
1970s

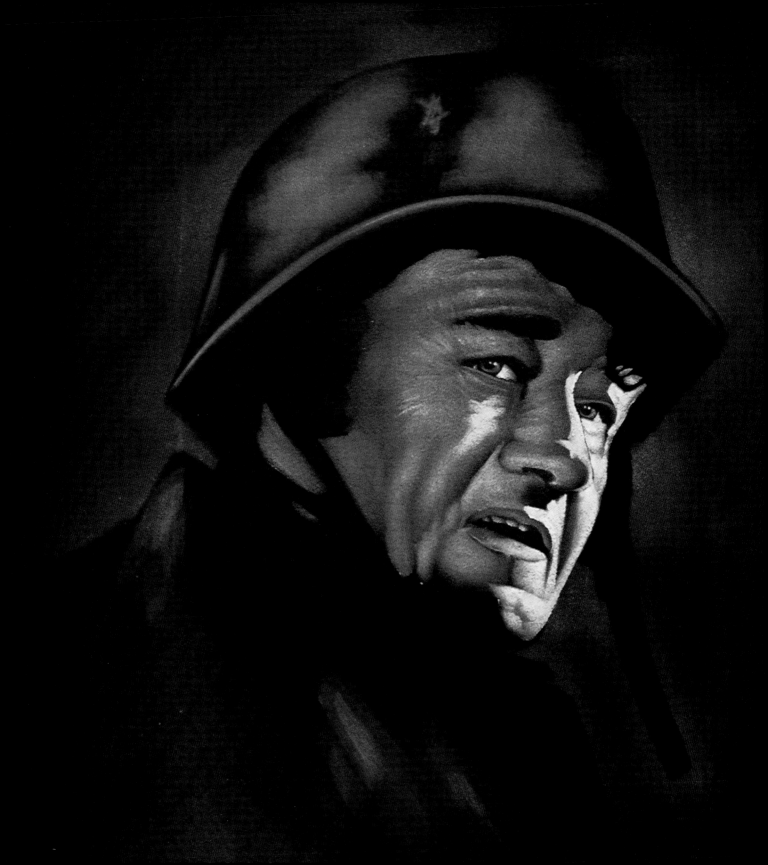

7 War is Hell

Sometime they'll give a war and nobody will come.

— "The People, Yes," Carl Sandburg

Here's The Duke again, warrior of the popular imagination, but most of these works are personal and poignant souvenirs, mostly from the Vietnam era, sent to parents or wives or girlfriends. The back of one bears the inscription, in small letters, "Dear Mom and Dad, this is what we look like here." Did these young men make it home, and where are they now?

LEFT: ARTIST UNKNOWN, *Sergeant Stryker,* Date unknown

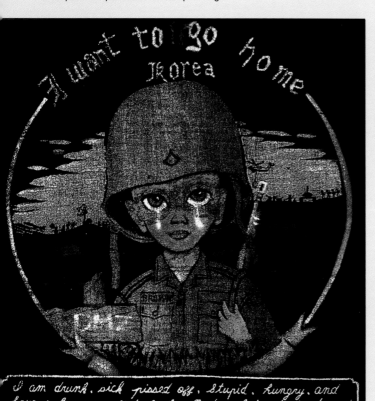

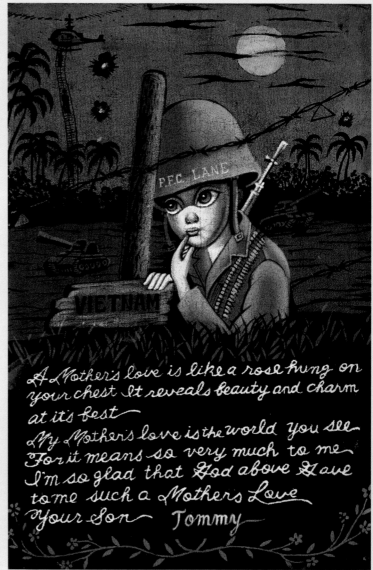

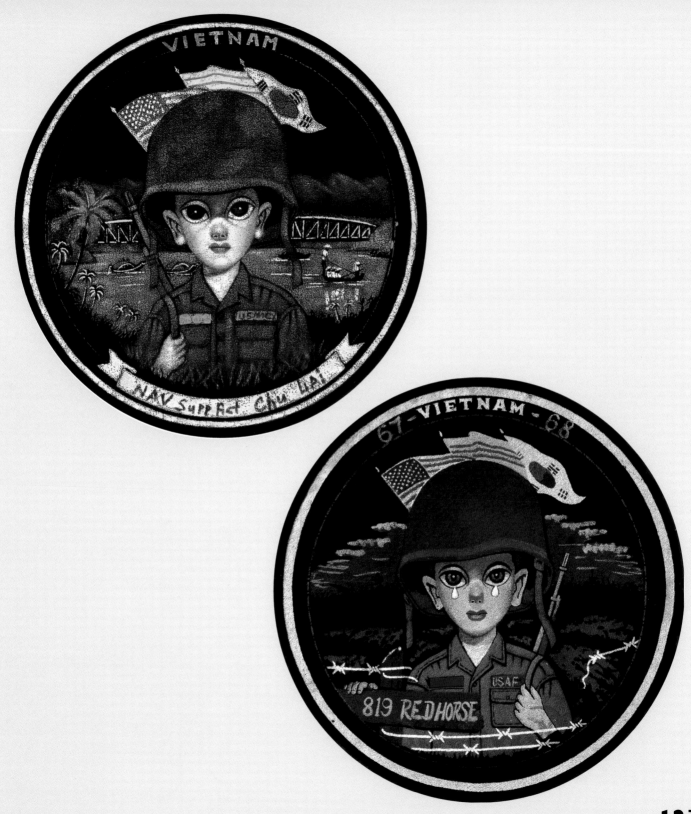

ARTIST UNKNOWN
Rescue at Sea
Date unknown

ARTIST UNKNOWN
Mitch
1978, Philippines

ARTIST UNKNOWN
World War II Portrait (Army Corps
of Engineers), White velvet
1970s

ARTIST UNKNOWN
Untitled
2006, Saudi Arabia

8 Masterpieces of Art

Rembrandt paints *Young Woman at a Half-Open Door* in 1645, in repressed and dreary Holland. More than three hundred years later, in sunny Hawaii, a man named Kim paints a beautiful copy on black velvet. Foppish, fresh-faced, attired head-to-toe in blue velvet, Gainsborough's "Blue Boy" resides in the Huntington Library's portrait gallery in California, while a copy painted by Sànchez on black velvet hangs in the Velveteria in Portland, Oregon. The Mona Lisa's smile is just as mysterious on black velvet, perhaps more so.

LEFT: JOHN M. KIM, After Rembrandt's *Young Woman at a Half-Open Door,* 1964

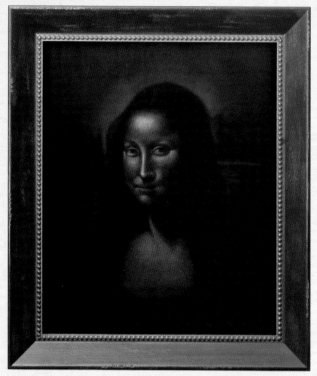

CECELIA RODRIGUEZ
After Leonardo da
Vinci's *Mona Lisa*
1970s

R. SÀNCHEZ G.
After Gainsborough's
Blue Boy
1970s

R. SÀNCHEZ G.
After Degas' *Ballerina*
1970s

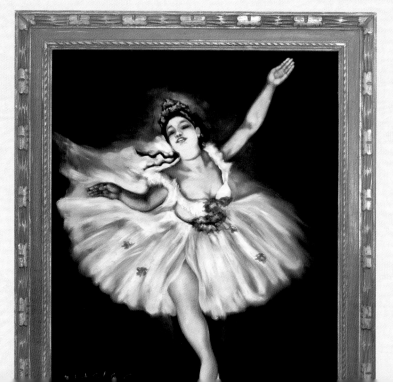

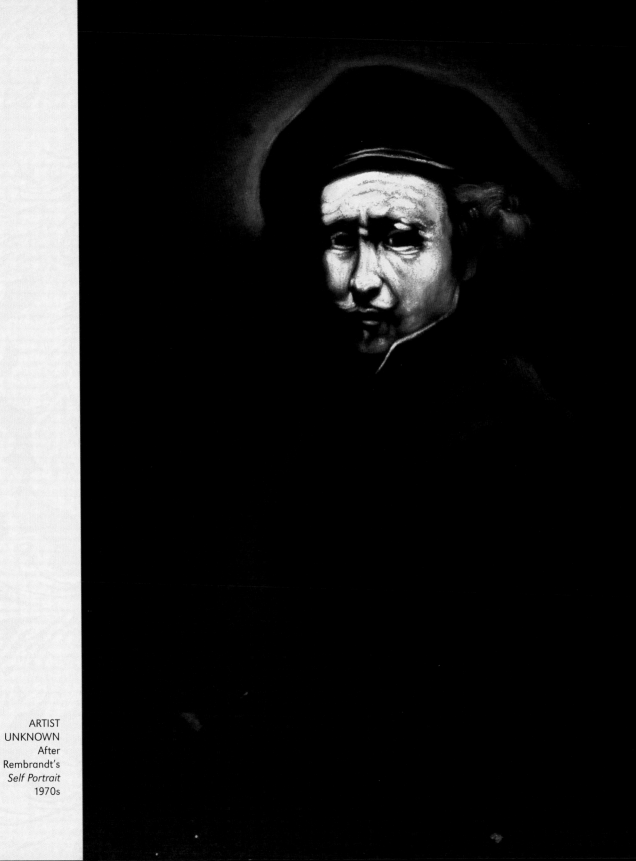

ARTIST
UNKNOWN
After
Rembrandt's
Self Portrait
1970s

ARTIST UNKNOWN
After Michelangelo's
David
2007

CECELIA RODRIGUEZ
King Tut
1970s

DON THOMOSON
The Sirens
1963

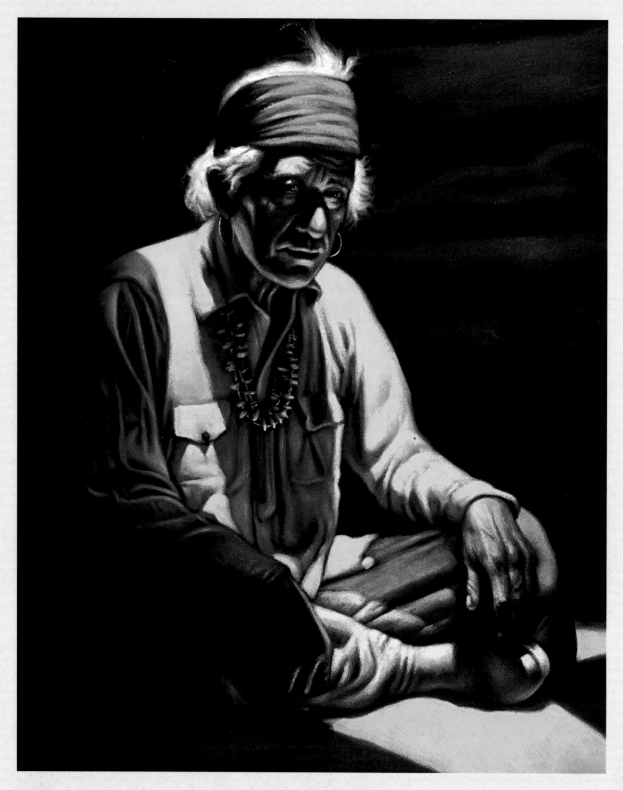

DANIEL GUERRERO
Untitled
Date unknown

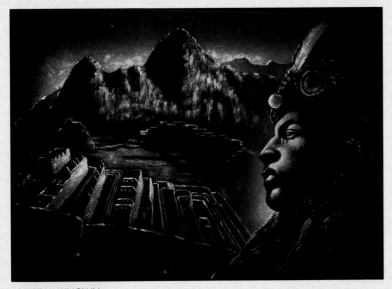

ARTIST UNKNOWN
Machu Picchu
2005

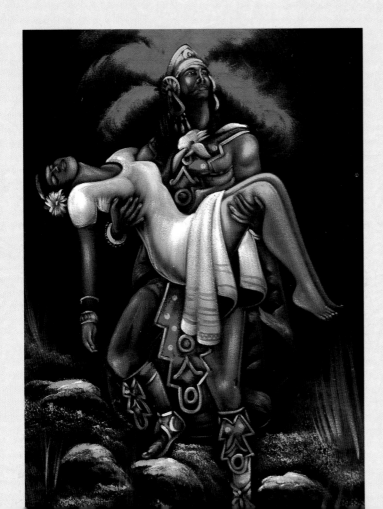

ARTIST UNKNOWN
Untitled
1970s

DANIEL GUERRERO
Untitled
Date unknown

137

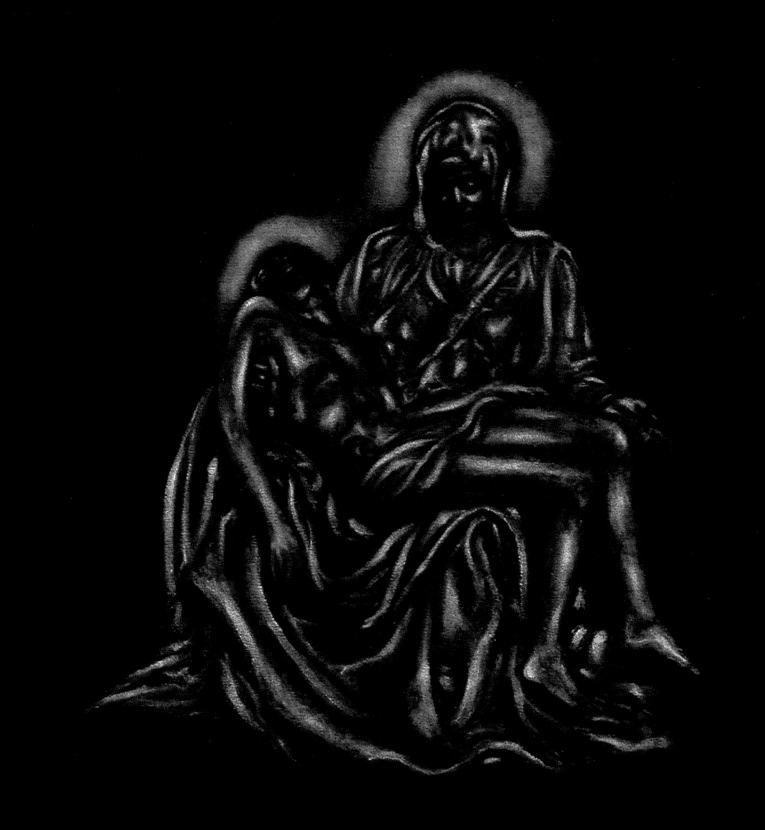

9 Jesus and Mary

Jesus, along with Elvis, is one of the most painted figures on black velvet. He is painted praying in the garden, hanging on the cross, walking on water, attending his Last Supper. He is depicted with arms stretched out over the world, eyes red with tears; in profile with a crown of thorns; and serenely standing with hands blessing a semi-truck. Mary is also a popular velvet vision, most often in the form of the beloved Mexican motif of Our Lady of Guadalupe, standing on a crescent moon.

LEFT: E. DEAN ALLISON, *Pieta*, Date unknown

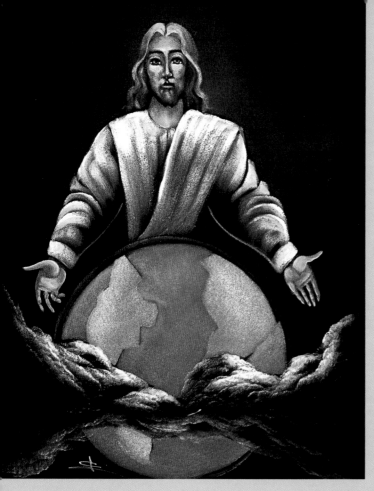

ARTIST UNKNOWN
Untitled
1980s

MEDINA
Our Lady of Guadalupe
2001

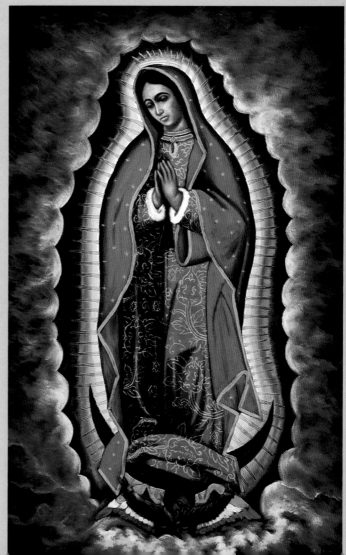

ARTIST UNKNOWN
God Bless Our Truckers
1980s–1990s

AGULTO
Guardian Angel
1970s

141

ARTIST UNKNOWN
Hand of Time
Late 1970s

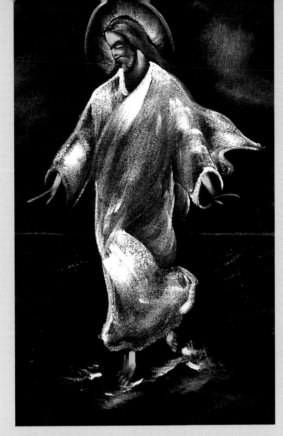

ARTIST UNKNOWN
Walk on Water
1970s

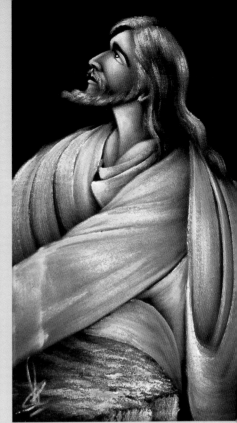

ARTIST UNKNOWN
Untitled
1970s

ARTIST UNKNOWN
Untitled
Date unknown

143

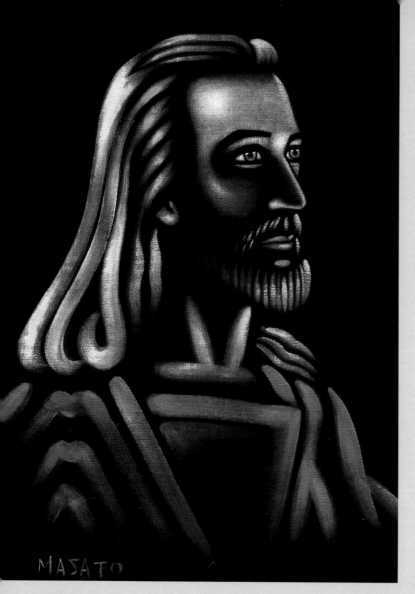

MASATO
Untitled
Date unknown

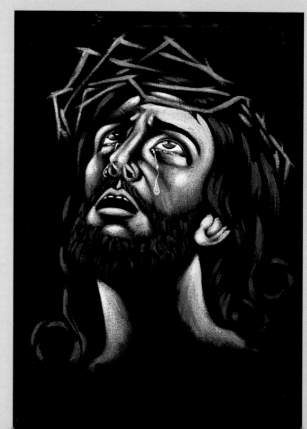

ARTIST UNKNOWN
Untitled
Date unknown

ARTIST UNKNOWN
Untitled
Date unknown

ROGER
Untitled
Date unknown

145

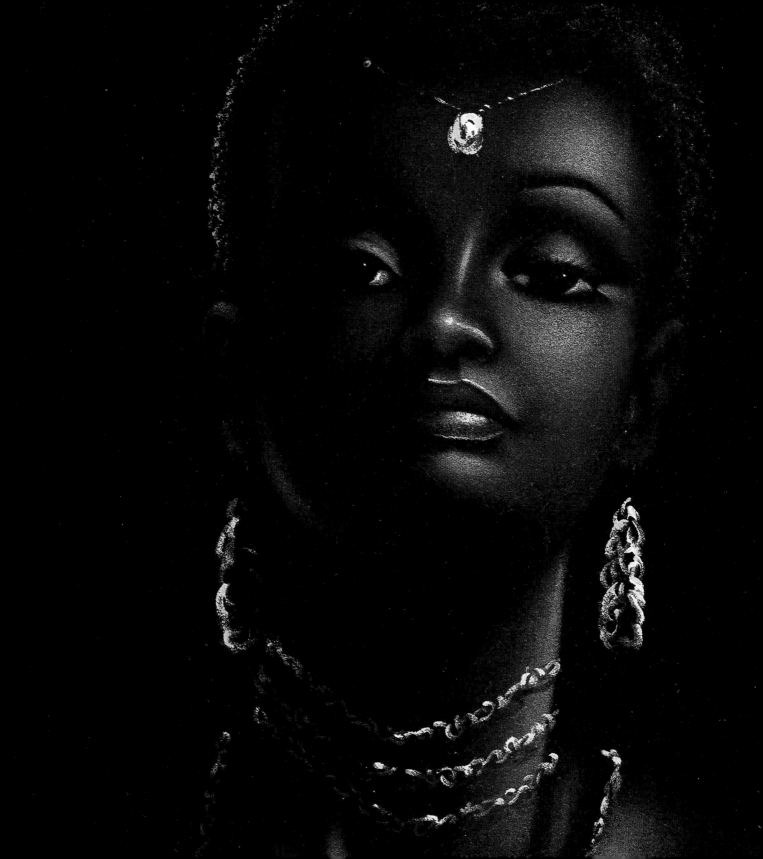

Black Velvet Power

Martyrs of the civil rights struggle Malcolm X and Dr. Martin Luther King Jr. are enshrined on velvet. BLACK POWER! Soul brothers and sisters with proudly stylized naturals say, "Black is beautiful." Ali floats like a butterfly, stings like a bee, and Dolemite, A.K.A. rapping Human Tornado Rudy Ray Moore, brings the Total Experience to the club. Pity the fools who don't know Mr. T and Oprah Winfrey are living the dream.

LEFT: LOAIZA, *Untitled*, 1970s

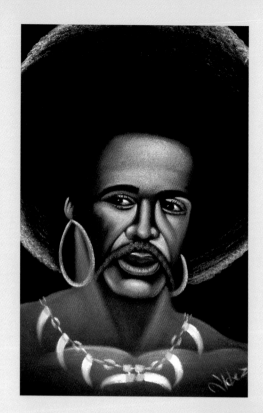

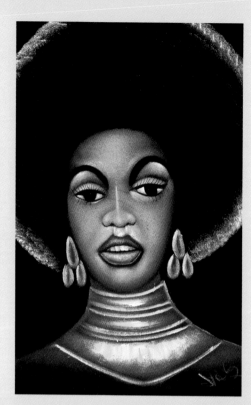

FAR LEFT
PEREZ
Untitled
1970s

LEFT
PEREZ
Untitled
1970s

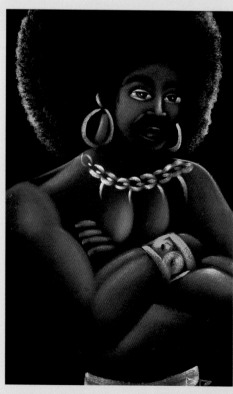

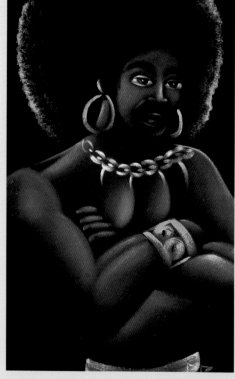

RIGHT
PEPE
Untitled
1970s

FAR RIGHT
PEPE
Untitled
1970s

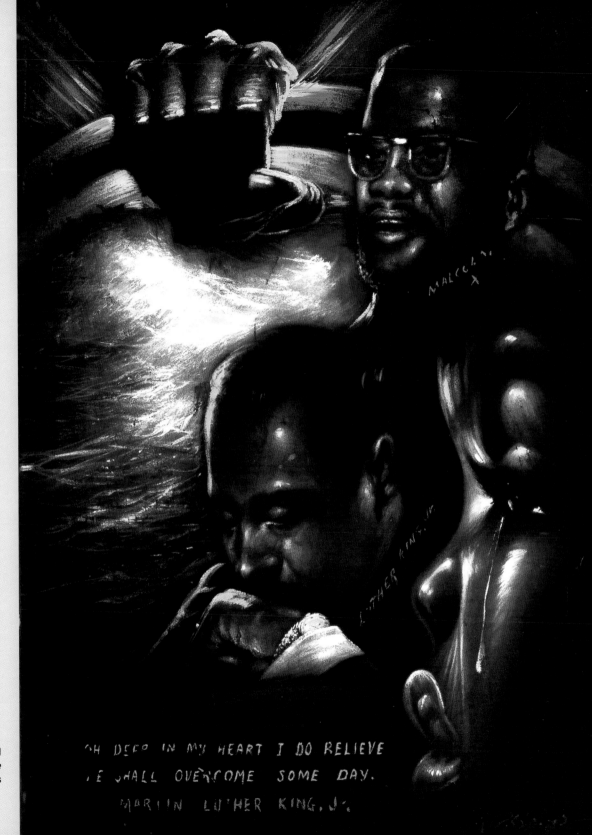

ARTIST UNKNOWN
We Shall Overcome
1970s

ARTIST UNKNOWN
Untitled
1970s

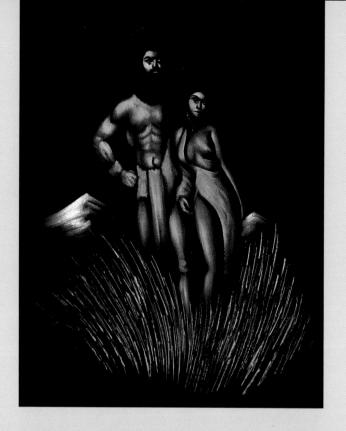

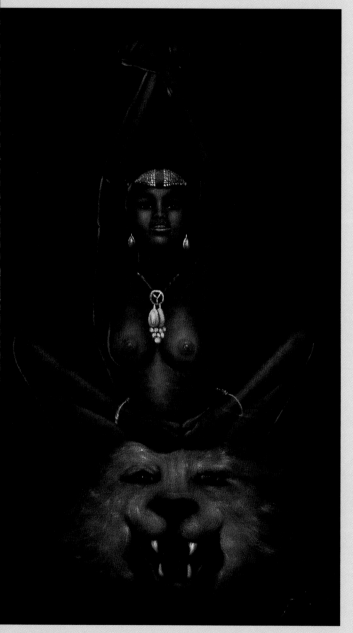

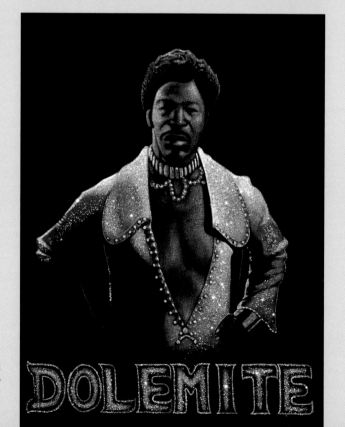

TANGUY
Untitled
1970s

RICHARD BUSTAMANTE
Rudy Ray Moore
2007

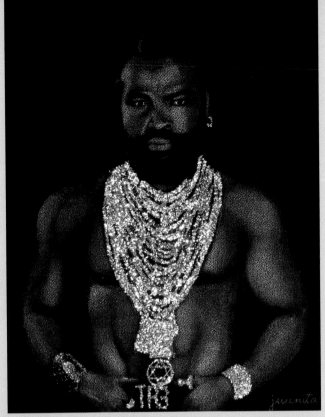

JENNIFER "JUANITA" KENWORTH
Mr. T
2005

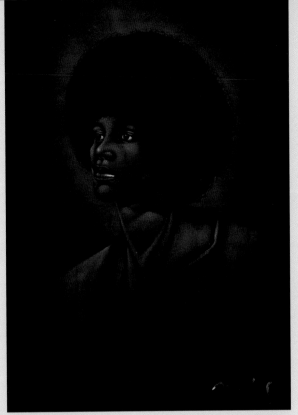

ARTIST UNKNOWN
Untitled
1970s

RICHARD BUSTAMANTE
Ali
2007

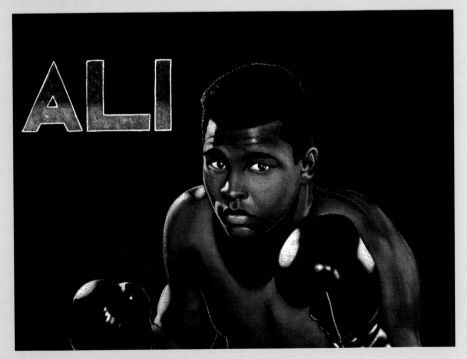

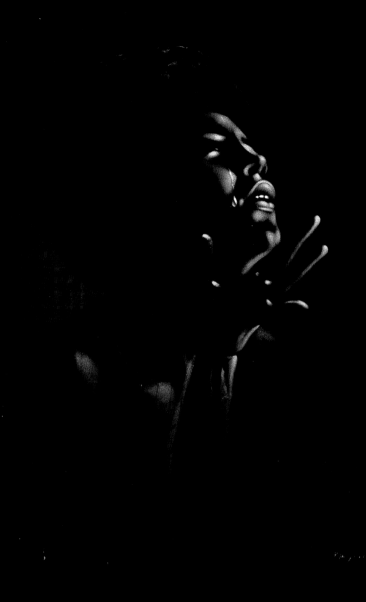

ARTIST UNKNOWN
Untitled
1970s

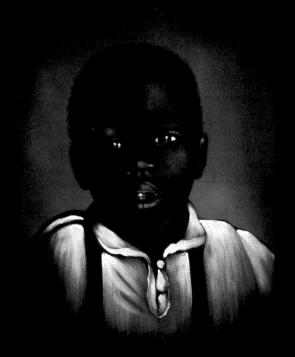

ARTIST UNKNOWN
Untitled
1970s

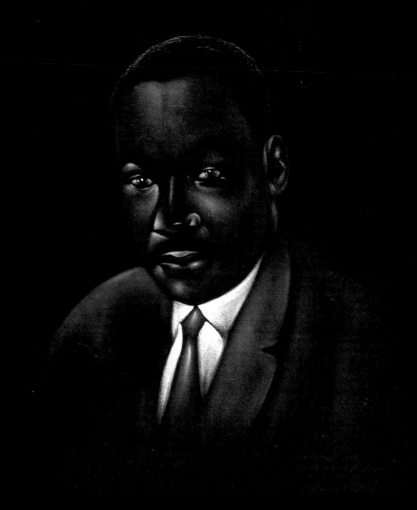

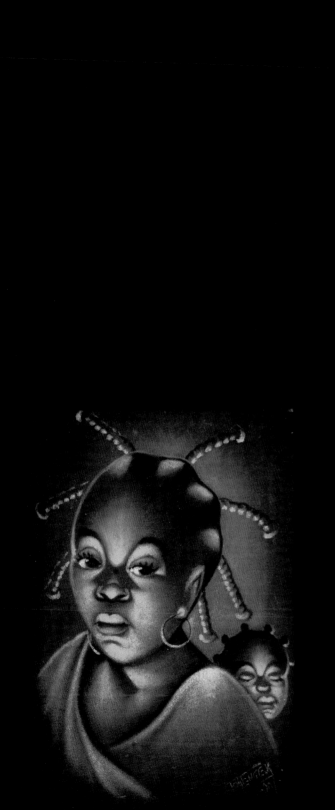

ARTIST UNKNOWN
King Luther
1970s

ARTIST UNKNOWN
Untitled
1970s

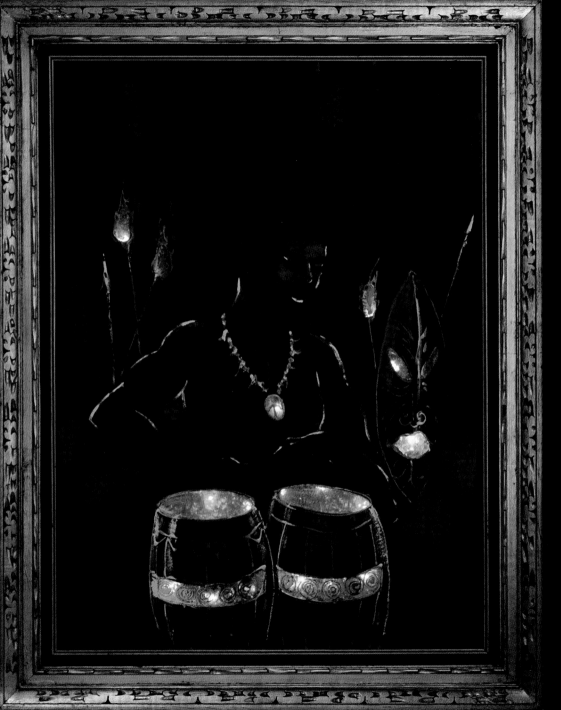

WILLIAMS
Untitled
1970s

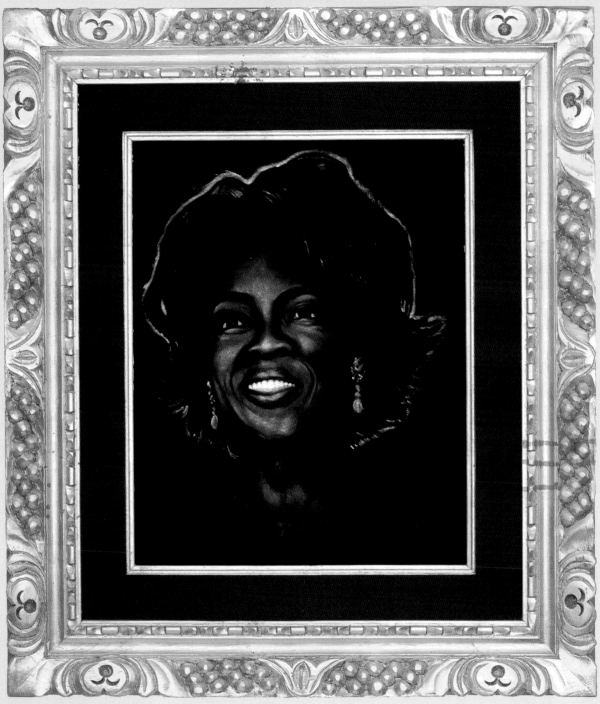

RYAN LEGLER
Oprah
2007

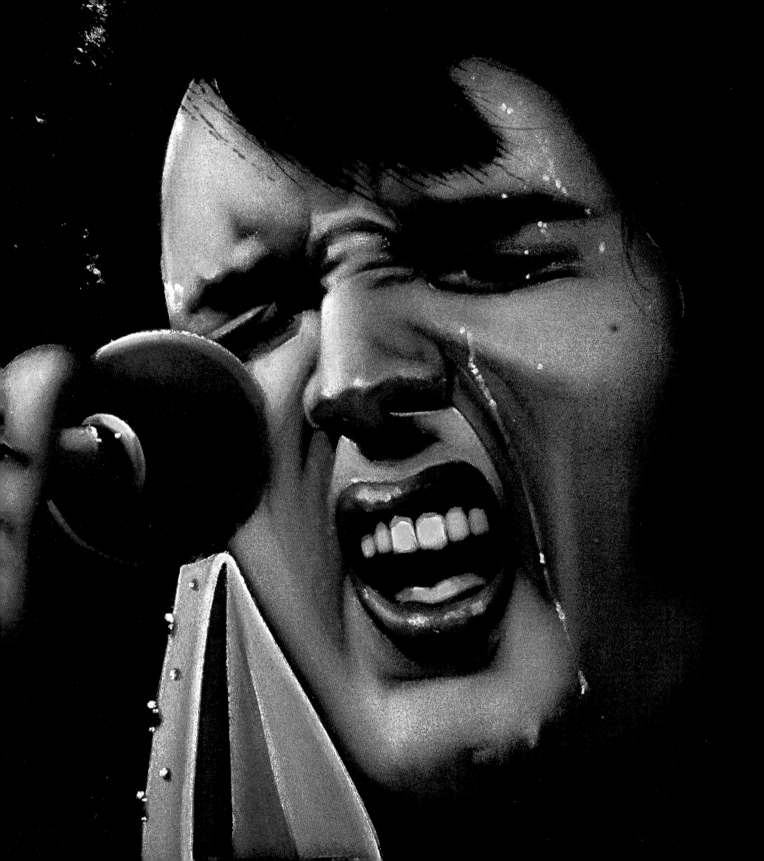

" Turn Up the Volume

See! the surgical evolution of Michael Jackson. Marvel! at the magical velvet mystery tour through the flower-power era of love not war, where the King and the Lizard King both reign eternally. Imagine! jamming, too, with Bob Marley, kissing the sky with Jimi Hendrix, sipping with Snoop, or marching in the KISS army.

LEFT: ARTIST UNKNOWN, *Elvis*, Late 1970s

"R"
Michael Jackson
1980s

ARTIST UNKNOWN
Michael Jackson
1980s

"R"
Michael Jackson
1980s

RYAN LEGLER
Michael
2006

ARTIST UNKNOWN
Jimi Hendrix
2000

ARTIST UNKNOWN
Jimi Hendrix
1970s

FELIX
The Beatles
1960s

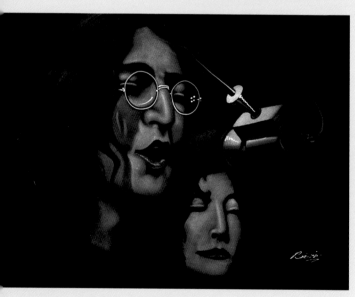

ARTIST UNKNOWN
John and Yoko
Date unknown

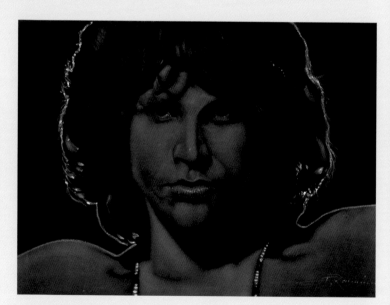

ARTIST UNKNOWN
Jim Morrison
2000

160

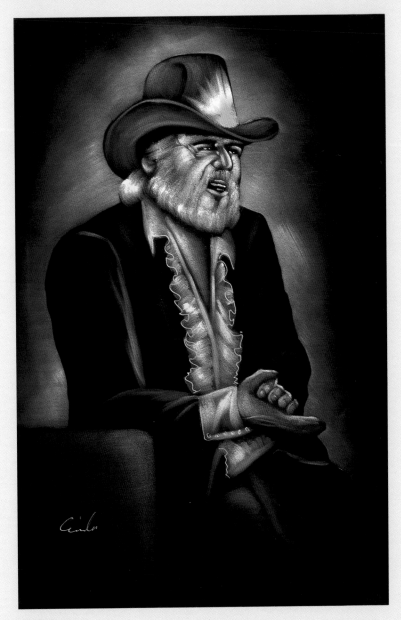

EMILIO
Kenny Rogers
Late 1970s

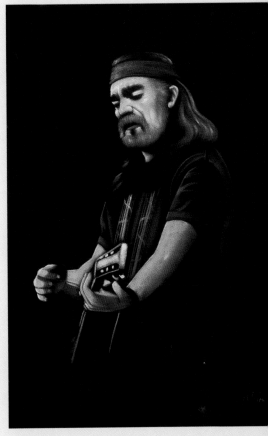

HUERTA
Willie Nelson
1970s

161

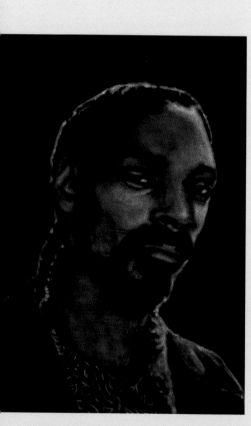

ARTIST UNKNOWN
Snoop Dogg
2007

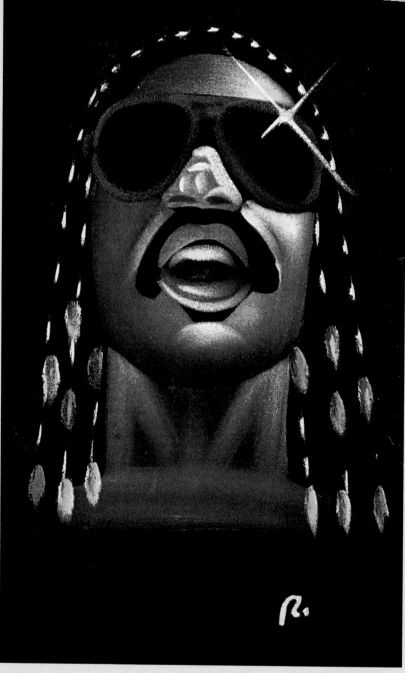

"R"
Stevie Wonder
1970s

ARTIST UNKNOWN
Isaac Hayes
1970s

ARGO
Bob Marley
2001

163

ARTIST UNKNOWN
Alice Cooper
1970s

ZUBIATE
KISS
Late 1970s

RYAN LEGLER
Howard Stern
2006

JENNIFER "JUANITA" KENWORTH
Frank Zappa
2006

12 The Weird

Jaw droppers and gourd poppers. Odd, strange, bizarre, and weird don't even begin to describe these mind-twisting eyefuls. Cross your eyes and cross your heart. It might be a bumpy ride, but it's always a soft landing on velvet.

LEFT: LEE, *Death in the Afternoon,* 1970s

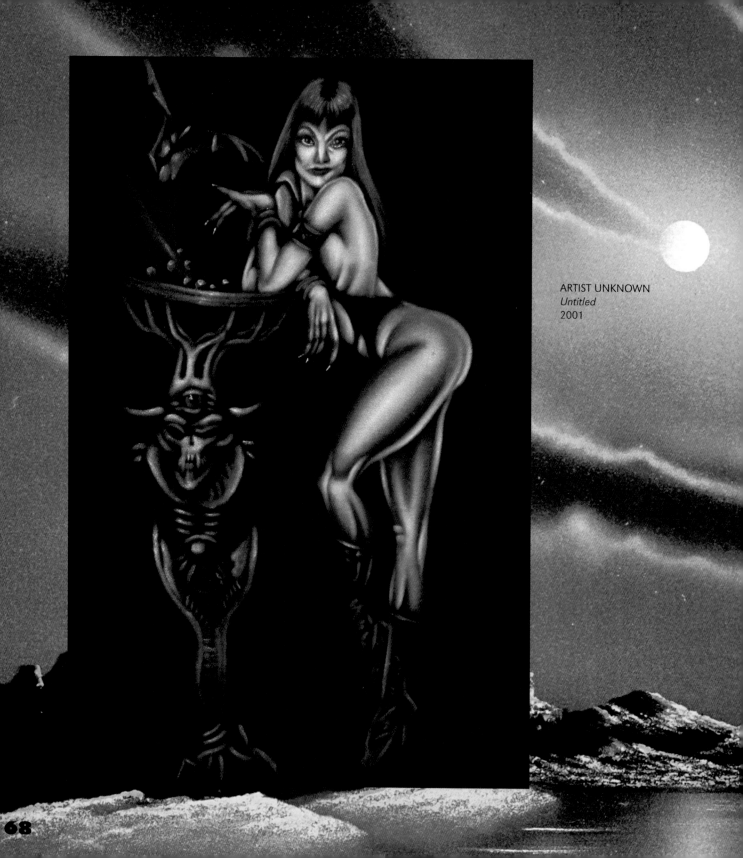

ARTIST UNKNOWN
Untitled
2001

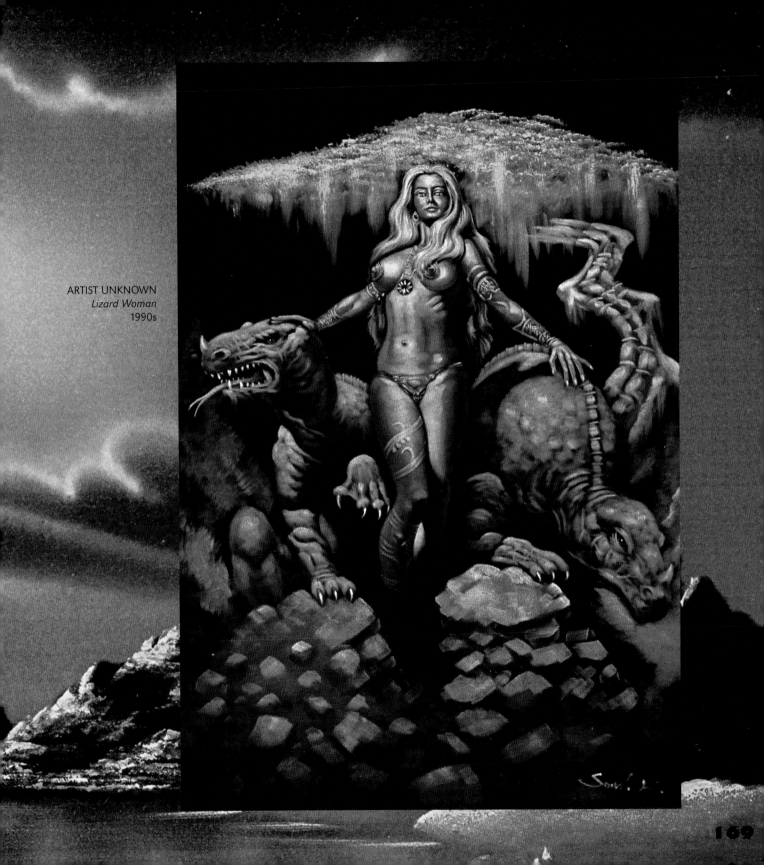

ARTIST UNKNOWN
Lizard Woman
1990s

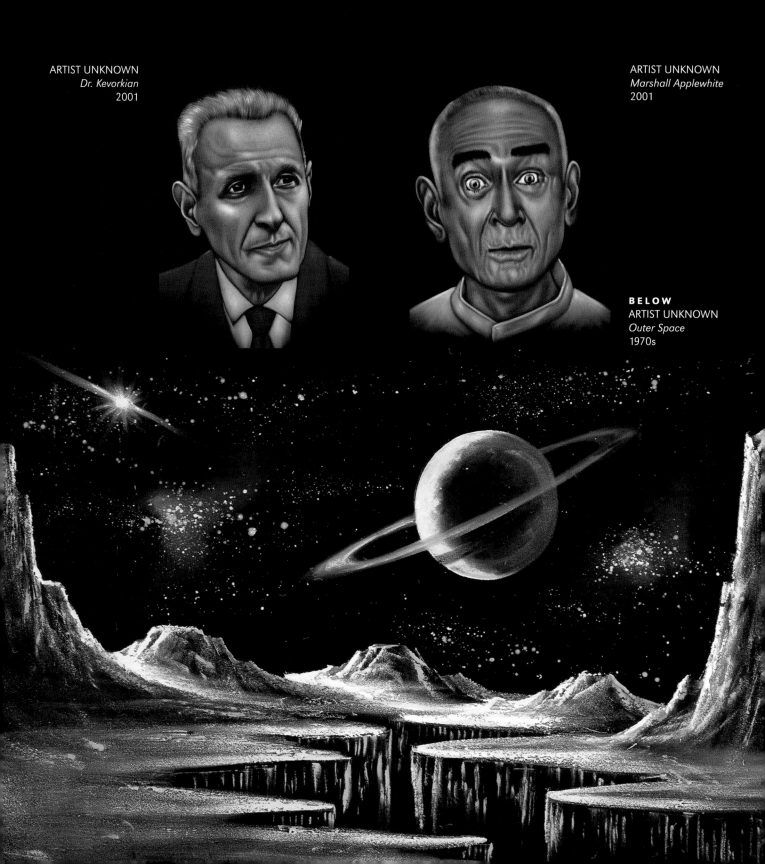

ARTIST UNKNOWN
Dr. Kevorkian
2001

ARTIST UNKNOWN
Marshall Applewhite
2001

BELOW
ARTIST UNKNOWN
Outer Space
1970s

BRIAN SMITH
Bat Boy
2007

LAURA HAZLETT
Untitled
2002

ARTIST UNKNOWN
Untitled
1970s

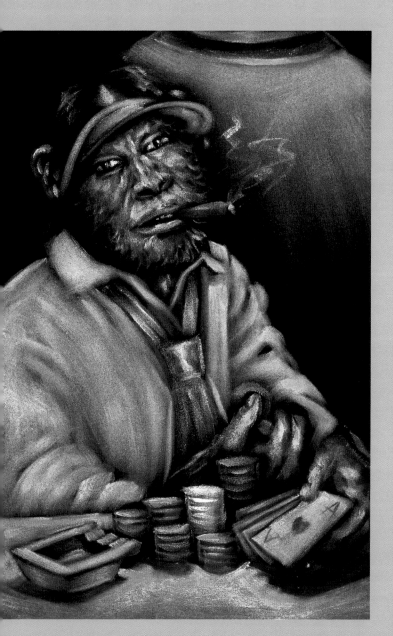

ARTIST UNKNOWN
Monkey Pit Boss
2001

ARTIST UNKNOWN
Untitled
1970s

RAT
Hulk Hogan
1980s

ARTIST UNKNOWN
Untitled
1972,
Philippines

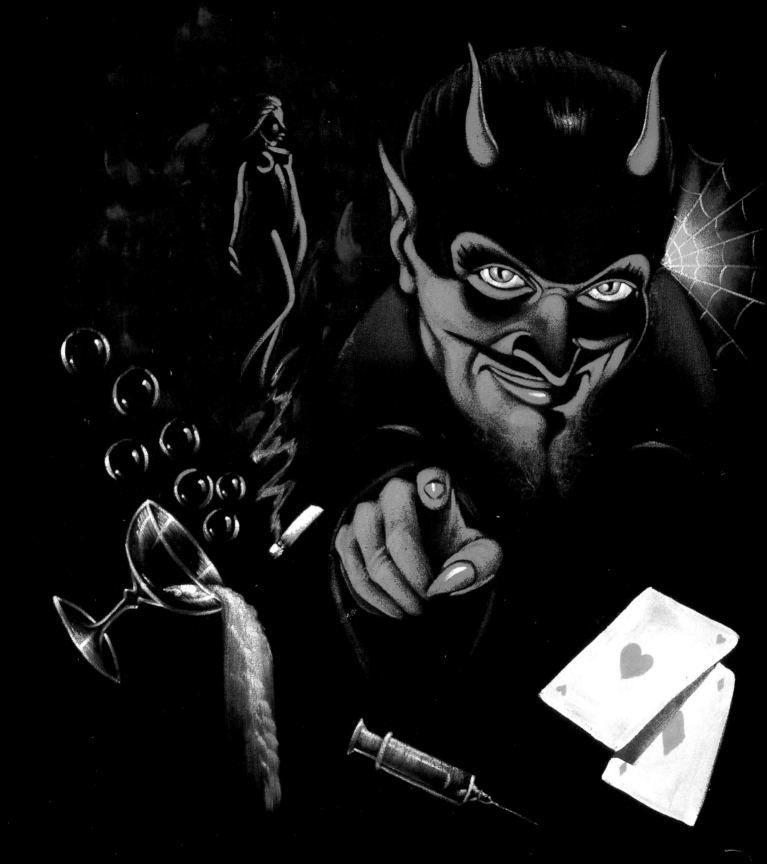

1₿ The Devils

Beware the Faustian bargain, the things your parents and teachers warned you about—surefire ways to wreck your life. Popular in tattoo art and on velvet, "Man's Ruin" is a cautionary tale. What could get you into more trouble than alcohol, gambling, and women (and on some canvases, a from-hell up-to-date crack pipe)? Check yourself before you wreck yourself.

LEFT: ARTIST UNKNOWN, *Untitled,* 1970s

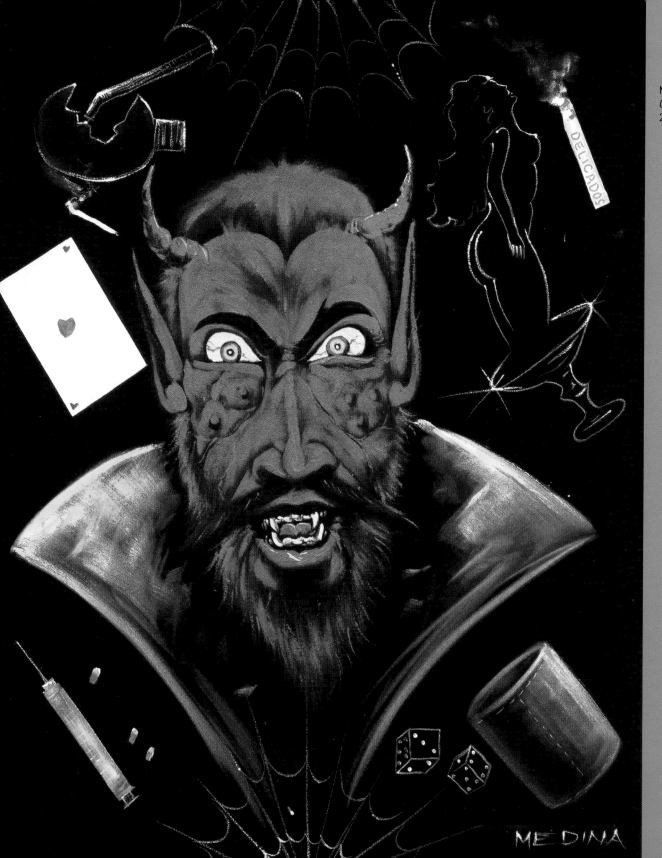

MEDINA
Untitled
2001

ARTIST UNKNOWN
Untitled
1970s

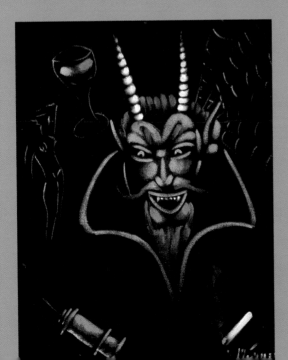

MARQUEZ
Untitled
Date unknown

ARTIST UNKNOWN
Devil on Throne
Early 2000s

177

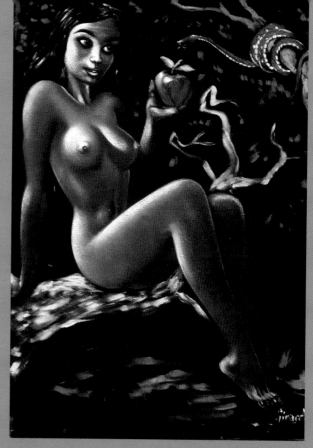

GIRARD
Eve
1970s

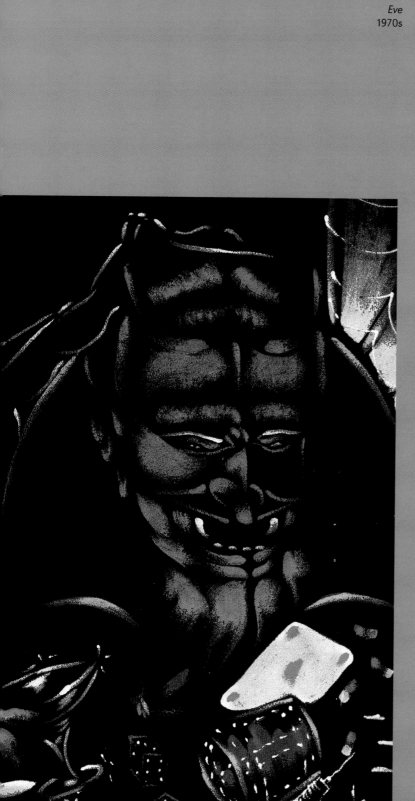

JOSE
Untitled
Late 1970s

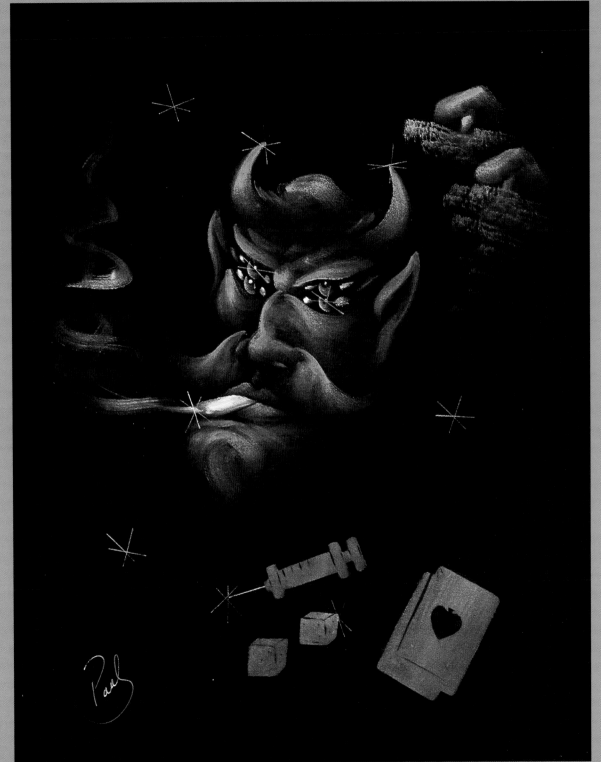

PAUL
Untitled
1970s

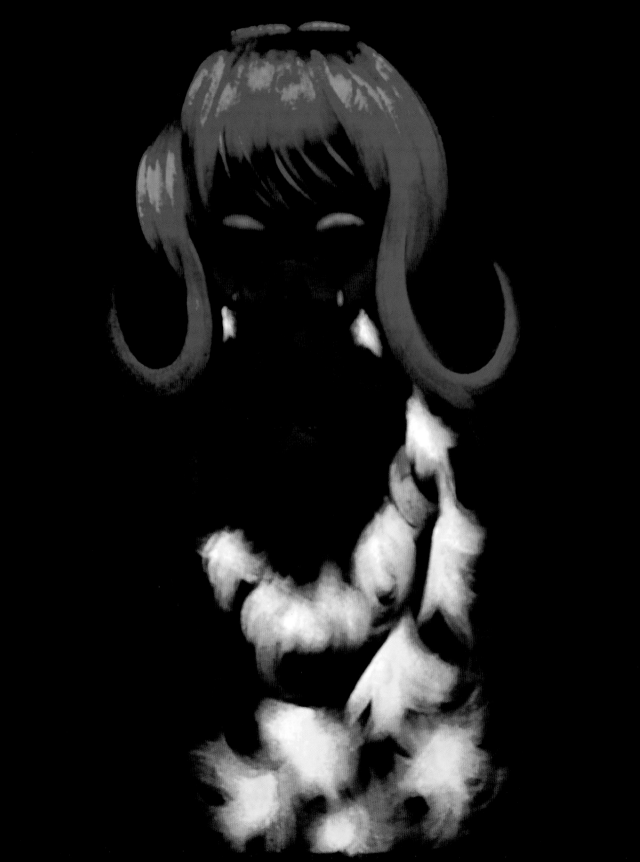

14 Black Light

Sit back, relax, and let your mind float downstream. Black light and black velvet—an unholy combination. The effect of ultraviolet light made visible by fluorescent paints presents a brighter than sane trip-out effect reserved by velvet painters for outré subjects and haunting fever dream visions. Black-velvet light bends the event horizon of time and space. You are having an out-of-body experience. Enjoy.

LEFT: ARTIST UNKNOWN, *Untitled,* Date unknown

SAKALIN
After the album cover for Savoy
Brown's *Hellbound Train*
1972

ARTIST UNKNOWN
Charioteer
1970s

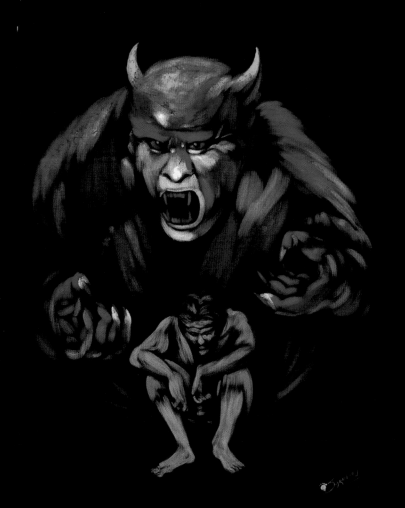

ARTIST UNKNOWN
Untitled
1970s

SAKALIN
Untitled
1973

ARTIST UNKNOWN
Untitled
1970s

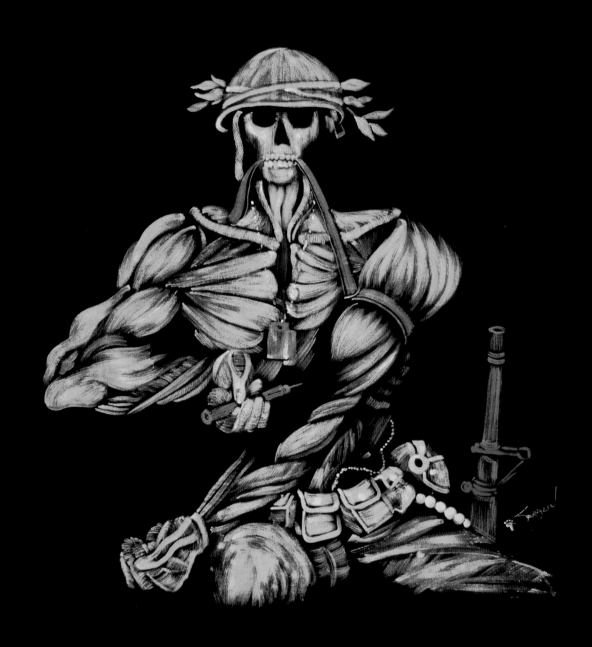

SAKALIN
War
1973

SAKALIN
Untitled
1973

ARTIST UNKNOWN
Untitled
1970s

RICARDO
Untitled
1970s

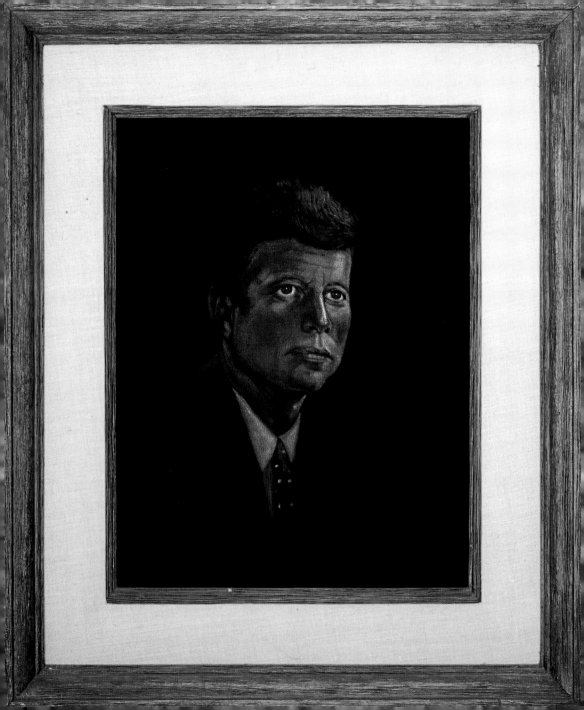

15 Eternal Flames

Their lives are seared forever in our memory. Liberace tinkles the keys. Marilyn is sexy, as always, and James Dean is the coolest teen. Princess Di remains the people's royal. JFK, once a man, now a myth. The Dragon lives, fury in his fists. Babe Ruth, the King of Swat, who called the shot. James Brown says it loud, we are on black velvet and we are proud.

LEFT: CECELIA RODRIGUEZ, *John F. Kennedy,* 1960s

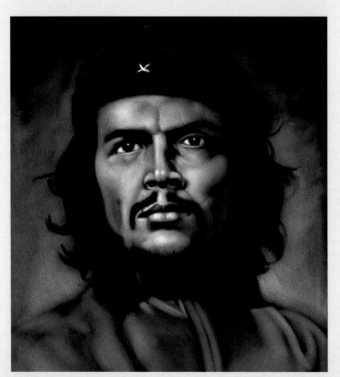

ABOVE LEFT
ARTIST UNKNOWN
Andy Warhol
2006

ABOVE
ARGO
Princess Diana
2001

LEFT
ARGO
Che
2001

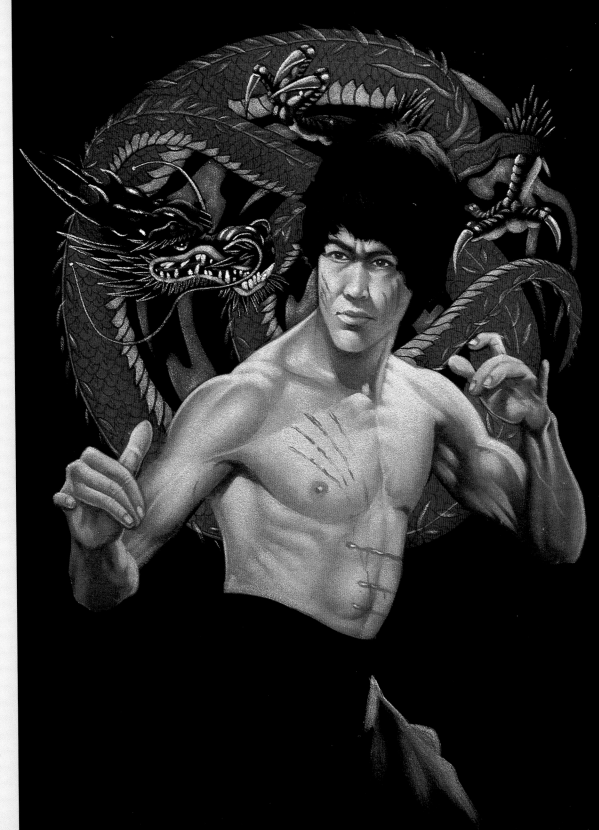

ARTIST UNKNOWN
Bruce Lee
Date unknown

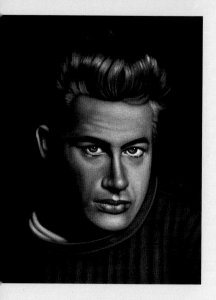

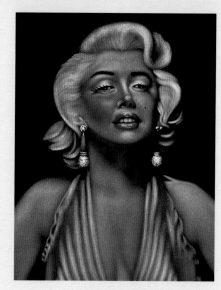

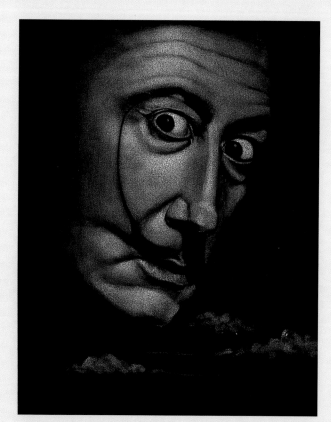

JENNIFER "JUANITA" KENWORTH
Salvador Dali
2006

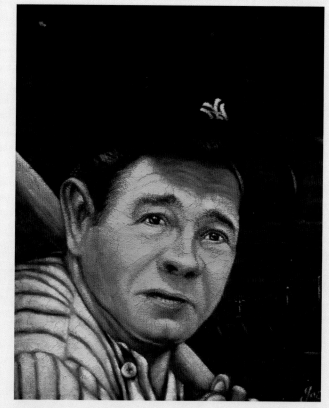

JOE KRC
Babe Ruth
1944

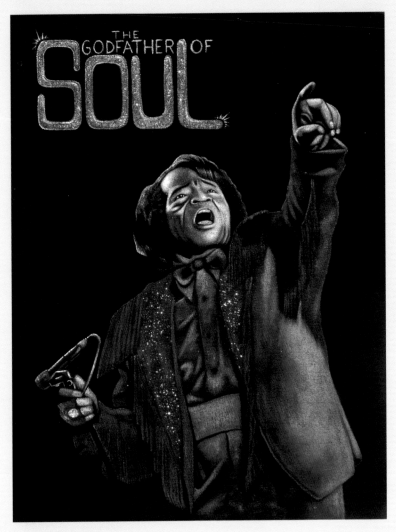

RICHARD BUSTAMANTE
James Brown
2007

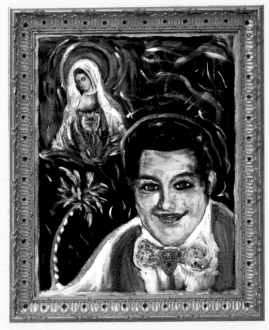

CAREN ANDERSON
Liberace
2002

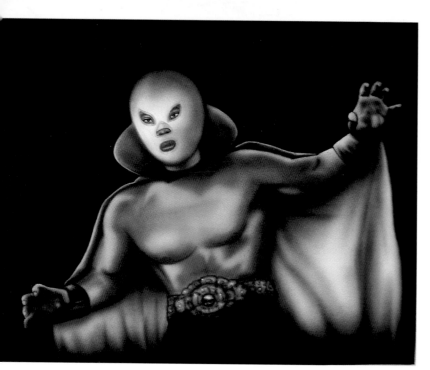

DANIEL P. MARQUEZ
El Susto
2003

Acknowledgments

We want to thank Mojo and Nacho, Steve Mockus at Chronicle Books, Reed Darmon, Anthony Bourdain, Tristan Jean, Belinda Covell, Alan Borrad, Rosalind Baldwin, Jennifer Kenworth, John Anderson, Sam Quinones, Ryan Legler, Rudy Ray Moore, Ronnie Raines, Ric San Pedro, Tempest Storm, Dixie Evans, Mr. Blackwell, Greg and Cathy Pitters, Dr. Loran Kitch and Wendy Kitch, Liz Renay, Efrain of Nogales, Sonora, Don Ho, Gypsy Boots, Samuel Fuller, Inara Verzemnieks, Dick Lane, Yolly, and the folks at Framing Resource.

ARTIST UNKNOWN
Timmy the Turtle
Date unknown